Poster for Priester Matches by Lucien Bernhard, 1902.

rogressive

GERMAN

Graphics

1900 – 1937

CHRONICLE BOOKS SAN FRANCISCO

Copyright © 1994 by Leslie Cabarga.
All rights reserved. No part of this book may
be reproduced in any form without written
permission from the publisher.

Library of Congress Cataloging-in-Publication Data
Cabarga, Leslie, 1954-
 Progressive German Graphics: 1900-1937 / by
 Leslie Cabarga.
 p. cm.
 Includes bibliographical references and index.
 ISBN 0-8118-0374-0
 1. Commercial art—German—Themes, motives,
 etc. 2. Graphic arts—Germany—History—20th
 century—Themes, motives. I. Title.
 NC998.6.G4C23 1994
 741.6'0943'09041—dc20 93-43600
 CIP

Editor: Carey Charlesworth
Book design: Leslie Cabarga
Translations: Marga Kasper
Art Photography: Peter Deierleine
Headlines set in KOBALT NEU,
designed by the author
especially for this book.

Printed in Hong Kong
Distributed in Canada by Raincoast Books,
112 East Third Avenue, Vancouver, B.C. V5T 1C8
10 9 8 7 6 5 4 3 2 1

CHRONICLE BOOKS
275 Fifth Street
San Francisco, CA 94103

INTRODUCTION

At first glance, the most striking qualities of German and Austrian graphic arts from the first part of this century are their weight and severity. Not all German design is unfriendly, however. Behind so much stern geometry a sense of playfulness prevails. In the writings of the old German designers they reveal themselves to be as solipsistically nutty as artists everywhere tend to be.

If historic circumstances and local conditions play a part in influencing design, as they are known to do, then at least the weight of German graphics has a social and historic foundation. Think of formidable stone castles. Think of the Bavarian oak and the massive pegged tables and riveted doors fashioned from its timber. Remember also the gothic blackletter types of Gutenberg and the grand tradition of heraldic symbols, and a context arises in which to understand the Prussian oeuvre.

It should not be surprising then that, steeped as they were in their own history, the Germans invented "modern." Two important movements, the Munich Secession of 1893 and the Vienna Secession of 1897—instances in which young artists rebelled against stifling and exclusionary established art institutions—made important steps toward derailing the inertial quagmire of German culture. German graphics are "progressive" because they eschewed the legacy of their surroundings to reveal truth. "Modern" means truth demonstrated by an acceptance of change. As the legend crowning Josef Maria Olbrich's Vienna Secession building so urgently explains it, "the time our art, the art our freedom."

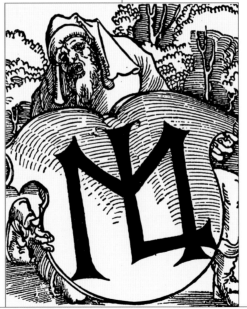

The beginnings of the trademark are revealed in this 1516 woodcut signet for Melchior Lotters, a Leipzig firm.

The Bauhaus, initiated in 1919, was another Secessionlike movement that brought forth brave new concepts of design. After its founders turned their attention to type and graphic design, the printed page was never again the same. Obviously German graphic designers were aware of the Bauhaus, since their work slowly began to echo some of its principles, yet the German commercial art publications at the time gave scant witness to the movement. Perhaps the pompous elitism of the Bauhaus allied itself more with fine art than commercial art—accounting for the many huge books on the Bauhaus that have been published in America, while this is the first American book on the broader topic of German graphic arts. Proof of the Bauhaus's impact is suggested, ironically, by the Nazis' suppression of it in 1933.

By the time Hitler had externalized his inner hell, setting it upon the world, most of his country's art and industry that was not subverted to the Nazis' needs had been diminished by wartime cutbacks. Thus this book shows the development of German and Austrian graphic arts mostly through the years of relatively free creative expression,

when the world still looked on in admiration.

ART FOR INDUSTRY

One need only consider the high quality of German and Austrian graphics to realize the great respect for the graphic arts held by these

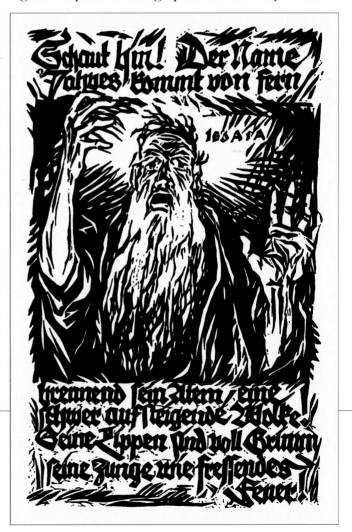

Rudolph Koch's dramatic book illustration, 1933, reflects the bold, angular strokes and heavy blacks characteristic of classic German woodcuts.

nations. It would be neither fair nor accurate to downplay the exuberant spirit of these arts in the rest of Europe, in England, France, and Italy especially, or even in America—yet the Germanic respect for *gebrauchsgraphik* (literally, useful art) or commercial art has always been great. As H. K. Frenzel, editor of the influential *Gebrauchsgraphik* magazine, explained, *"Gebrauchsgraphik* is not free graphik whose purpose it is only to serve an artistic intention, but it is graphik bound to purpose, it is an artistic means for the expression of a definite intention toward commercial propaganda."

Even as American illustrators of the early twentieth century like Charles Dana Gibson and Howard Chandler Christy basked in movie-star-like adulation from the press and public, their printed work was seen more as an amusement or decoration than as a necessity to industry. Not until the 1930s did the concept of industrial design even begin to emerge in America. Before that time, most manufacturers were designers only by virtue of whatever inevitable, perfunctory arrangement was achieved by default. To this day the American graphic artist is largely looked upon by the manufacturer and the advertiser as a necessary evil,

barely tolerated as the budgetary inconvenience he represents and resented for asking a price for so dubious and intangible a commodity as creativity. Unfortunately, many manufacturers today seem to view a material, like plastic, as having worth, but much less so the value of the design that molds the plastic into something saleable.

Not so in German industry. Business owners came early to the awareness that the difference between soap and soap often lay in visual appeal. In Germany and Austria the importance of making all commercial products artistically as well as functionally sound was recognized by the turn of the century. The Wiener Werkstatt of 1903 (and later the Bauhaus movement) sought to remove barriers between artists and craftspeople. Its disciples reiterated the commitment to bring art—progressive concepts of art at that—to all aspects of graphic design, architecture, and manufacturing. The Deutsche Werkbund, (German Work-Association), established in 1907, was another effort to bring about collaboration among artist, manufacturer, and merchant. Its concept: involve the artist during the developmental phase of production to improve the standards of both product and design.

Opposite, tradeshow exhibition stand for the paper manufacturer Gerasch, c. 1924. Note the display of posters by Ludwig Hohlwein.

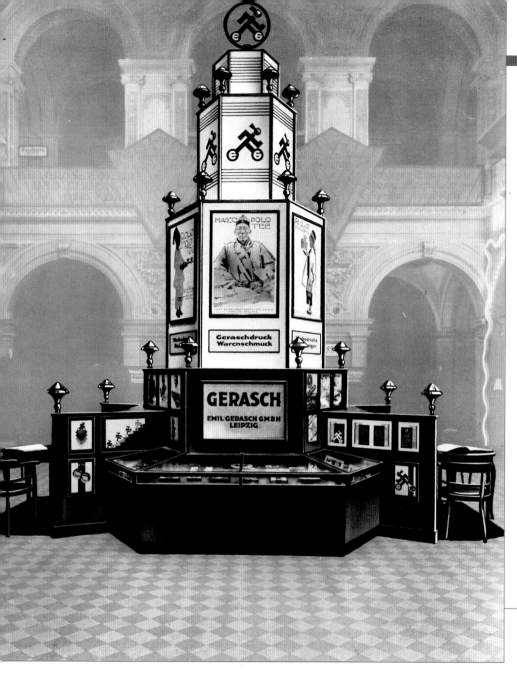

Recalling the result of such movements, Carla Binder, widow of the great Austrian poster artist Joseph Binder, wrote, "It was obvious that a dramatic change was under way. Everything was new—from the cup in your hand to the chair you were sitting on. Acceptance by the general public was evident by the growing influence on day to day life."

In 1927 the British publication *Commercial Art*, commenting on the German stylistic tendency toward "hard and severe formalism," conceded, "It is clear that commercial art and artists hold a position in Germany they have not yet attained here." Further, whereas German advertising men were said to have much to learn from British

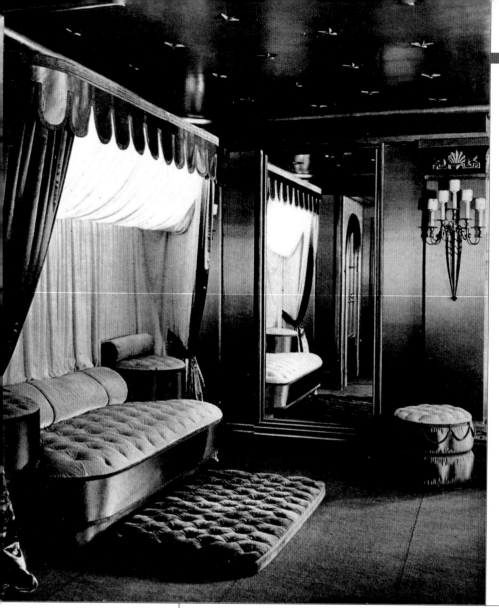

and American principles and methods, the "German cooperation between scientist, artist, and merchant... [and] the German movements and creations in applied art certainly offer much food for thought to advertisers in England and other countries."

As German tradeschools sprang up in every manufacturing district, the manufacturers enrolled their sons to learn the fine points of their trades and, as well, to be educated in the creation of artistic design. What was designed in the classroom was then taken to fruition on the bench. Such thorough, all-around training was also prevalent in Austria, where a young person who served an apprenticeship at a trade was also compelled to go on to special schools for even more intensive training, to "fill in the gaps" of education.

Much of this training, beginning with a study of basic, geo-

Above, Lucien Bernhard's creativity expressed itself in myriad directions including interior architecture, like the boudoir above in midnight blue and gold, 1929.

metric forms, taught the interrelationship of all forms of design. Thus prepared, an unprecedented legion of German industrial artists set forth to add beauty and organization to the clutter of commerce. These designers were qualified to handle every aspect of commercial art and industrial design. They tackled letterheads, trademarks, packaging, and product design with equal enthusiasm and ability. Most were able poster designers and illustrators with ability in type and lettering as well as drawing human anatomy. Further, they designed impressive tradeshow exhibits containing massive three-dimensional structures, provided furniture and interior designs, and—since many were also trained as architects—drew plans for houses and buildings as well. With such versatility it shouldn't be surprising to discover fine woodcut illustrations by Rudolph Koch, who is known mainly as a designer of calligraphy and type, or lavish interiors by Lucien Bernhard, the poster and type designer. Quality in art is a subtle thing, registering on even the untrained viewer in at least the subconscious mind, so that even the simplest, most highly stylized images, such as trademarks, benefit from a designer's ability to draw well. And fine rendering is also impor-

tant in product design and representation; that which an artist cannot express in a drawing certainly cannot be conceived in three-dimensional reality. At the other end of the spectrum, for artists possessing such ability as that of Austrian painter Gustav Klimt, or even German designer F. H. Ehmcke, making a poster is like taking a holiday.

THE POSTER

The advent of the poster marks perhaps the most significant step in Germany's ascension to worldwide fame in the graphic arts. Yet the Germans were relative latecomers in the field of advertising. During the latter half of the nineteenth century the push of industrialization was felt less strongly in Germany than elsewhere due to the insularity of its many independently ruled principalities. Consequently, Germany had less contact with the outside world.

In the small German communities, all trade depended upon personal contact between merchant and customer. Advertising, such as handbills or posters, was virtually nonexistent. Early users of posters were travelers, such as itinerant salesmen or circuses that needed to announce imminent arrival in town. Ever increasing indus-

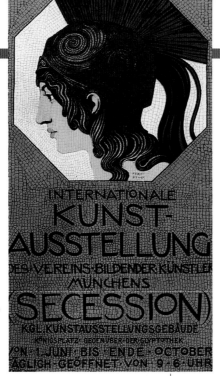

trialization began to change this situation; as more goods were produced, more competition evolved. New conditions in the marketplace emerged as more people gravitated to industrial centers, which formed the nuclei of future great cities.

The presence of these new paper heralds, the posters and handbills, was at first quite unassuming. Two forms predominated: small, printed woodcut or copper engravings consisting purely of type, with only an occasional black and white illustration, and larger, full-colored pastoral scenes—stock images, actually—to which miniscule advertising messages were added. The publicity value of the latter form proved nearly nil. The very first posters to display a more sophisticated visual appeal were those created by artists or artisans to advertise their own wares or exhibitions.

In Berlin, the most cosmopolitan city from among the principalities, a cacophony of posters covering walls soon led to the adoption of circular pillars just for these notices. Known as *Litfasssäule* (Litfass pillars) after the entrepreneur Ernst Litfass, who first erected them in 1855, they are still seen throughout Europe. In the comparatively bucolic southern city of Munich, where Prince Lietpold, the monarch of Bavaria, resided, German culture flourished. Here artists and artisans from all over the country came to partake in the artistic environment. About 1880, when posters finally began to appear in Munich, they were at first displayed inconspicuously but soon began to usurp wall space, to the distress of the locals. Just as serious opposition to the new advertising began to be voiced, a new species of poster appeared in Munich.

In 1883 Prof. Rudolph von Seitz, an academician, designed a huge and elaborate poster for an art exhibit in which he took part. The graphic style had elements of the old medieval manuscripts. Because of the familiar imagery it evoked its intrusion on the architectural land-

*Above,
considered amazingly simple for its time, the
Kunst Austellung Secession (Secession Art
Exhibit) design, 1886, ushered in a new genera-
tion of posters and poster artists.*

scape was less objectionable. For all its sophistication, however, this and subsequent "artistic" posters filled many traditionalists with rancor—but not the public at large. It was the young artists whose works were barred from the academic exhibitions these new posters advertised who established the Munich Secession, to better exploit their own, more modern point of view. They protested against the belief that only huge easel paintings were "art." Wishing to deal with contemporary situations instead of religious allegories, they easily gravitated to the poster form. Instead of presenting full figures and elaborate borders, the new posters stylized details and simplified the message. Some of their posters even lampooned those of the established artists. In their great number, the

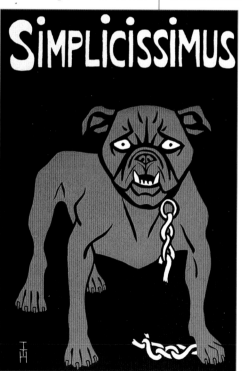

young artists of Munich organized galleries and exhibitions to sell their wares. Their posters for these shows reflected a fresh approach. Moreover the bold, aesthetic appeal and often humorous content helped disguise the advertising intent, which deflected criticism of their presence on public walls. Subliminal advertising was born!

While Munich was still "inventing" the poster, the art was already flourishing in Paris and London. Jules Cheret and Toulouse Lautrec of Paris had by this time already begun applying their prodigious talents to the mundane service of the most ordinary merchants. It would have been unthinkable for such posters—sexy girls with low-cut gowns advertising motor oil—to appear in Munich at that time.

In 1896, the magazine *Simplicissimus* (Simplicity) made its debut, announcing its appearance with a bold and simple poster of a solid red bulldog against a black background. It is hard now to

Above, this poster by Thomas Theodor Heine for the influential, avant garde journal Simplicissimus, 1896, *also served as its cover.*

13

imagine the impact this poster made upon a public completely unused to such stark, simple graphics. But this magazine, and another titled *Jugend* (Youth)—both of which contained political satire—were to become the focal point of the youthful, bohemian art movement in Munich. Their radical commentary was allowed to exist—even protected to some degree—because Prince Lietpold knew that it irked Kaiser Wilhelm, whom he despised.

Drawing inspiration, it was said, from American magazine covers, *Simplicissimus* founder and cover artist Thomas Theodor Heine helped to make clear the function of simplicity in poster design. So much more compelling were these new German posters that they began to attract the attention of merchants. At first they adopted the complex graphics of the art academy style poster. But merchants soon realized that this approach failed to arrest the viewer's attention or compel him to buy. The new, abbreviated graphic form of poster soon proved the superior sales vehicle.

Meanwhile posters had begun to appear throughout Germany. An 1898 competition held

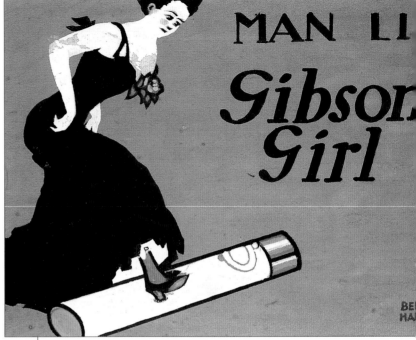

by Pelikan, a manufacturer of art materials, drew about five hundred entries. In a 1902 poster competition held in Berlin by the Priester match company, design was brought to a previously unimagined degree of simplicity in teenaged Lucian Bernhard's winning entry. Bernhard's innovation led to a craze in Berlin for the *sachplakat* (object poster) in which a

Above, an original sachplakat *rough comp by Lucien Bernhard, 1909, for Manoli's Gibson Girl brand cigarette. Bernhard apparently didn't bother to finish the Manoli lettering.*

picture of the article being advertised became the focal point of the poster. Although Bernhard subsequently turned out dozens of them, none ever matched the initial inspiration for Priester. The power of the object poster soon dwindled, exhausting itself in eternal repetitions. Despite the enormous reputation he was to achieve in Germany, in 1922 Bernhard made New York his home (he later lamented having been born "on the wrong side of the Atlantic"). It took almost

five years with few commissions, however, before his modern approach won acceptance with American art directors.

H. K. Frenzel wrote that the *sachplakat* could only have come from Berlin, "with its feverish development as a world city and the frantic speed of its traffic." In Munich, in fact, an artist with a very different style became poster king. The German name for the southerly city, München, that was always placed below the signature of Ludwig Hohlwein suggested by its inclusion the stylistic schism that developed between north Germany and south. Hohlwein's "romantic" style seemed an outgrowth of Munich's cultural environment. Initially, anyway, both Hohlwein and Bernhard claimed to have drawn inspiration from the extremely pared down posters of two Londoners calling themselves the Beggarstaff Brothers.

From their beginning in about 1906, Hohlwein's poster designs eventually numbered in the hundreds. His unerring color and design sense and his superb drawing and lettering ability brought him to international fame. He relied heavily on photographs and "swipes" from magazines for the main subjects in his posters (as artists still do). The two extremely

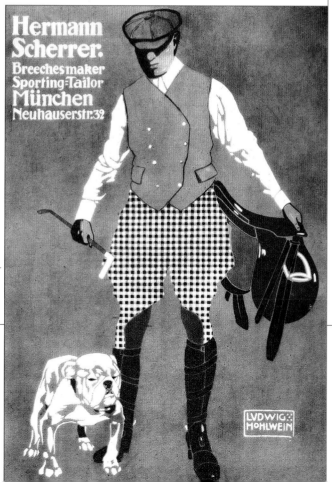

One of Ludwig Hohlwein's first posters, for Hermann Scherrer, the Sporting Tailor, 1902.

15

(The Six), who included the well-regarded Valentin Zietara, established one of the first commercial art studios. As a sales gimmick each of the six partners prepared a rough sketch for every job received, giving their clients a wide choice.

Despite its similarly Germanic culture, Austrian art developed its own characteristic flavor. Modern posters evolved in Vienna at the hands of Secessionist artists, like Koloman Moser and Gustav Klimt (much as Munich's early posters were by artists promoting their own exhibitions). One man in particular, Julius Klinger, was to define the Austrian poster style and become its foremost exponent. The Austrian Klinger, who began his career in Berlin, had a style that would have been considered unusual in any time period. His work appeared to be that of a designer more than a painter-cum-poster artist, and his lettering was

rare Hohlwein originals I've seen were small— less than eight by ten inches. Apparently the lithographic artists who enlarged his watercolor paintings and rendered them onto the printing stones (improving some small details in the process) helped considerably to increase the master's output. Against Hohlwein's hegemony, a group of poster artists calling themselves *Die Sechs*

Above, a typical object "poster" for Urbin shoe polish.
Sachplakaten *were considered revolutionary because of their stark, blatant advertising approach.*

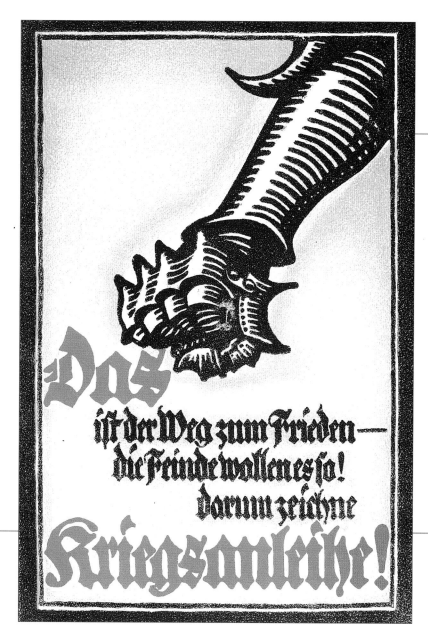

Lucien Bernhard's poster for a war bond drive, 1918, pleaded, "This is the way to peace—the enemy wants it that way." It is one of the first of the German World War I posters with imagery rather than lettering only.

always first rate. Key to Klinger's posters were economy, simplicity, and overall white backgrounds. With a personality apparently as idiosyncratic as his work, Klinger wrote, in 1923, "The backs of our sober designs are smeared all over with paste, but on their fronts we build up our world picture with maddening conscientiousness.... In order to be able to picture a razor blade indelibly we steep ourselves in the mysteries of paleolithic art."

THE GOLDEN YEARS

Although German industry came to an abrupt standstill in 1914, World War I inadvertently had a positive effect on posters (as it did

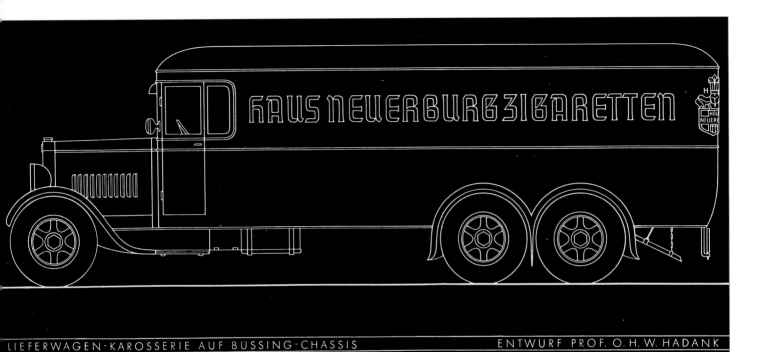

LIEFERWAGEN·KAROSSERIE AUF BÜSSING·CHASSIS — ENTWURF PROF. O.H.W. HADANK

in America and elsewhere). In fact, the German Reich dragged Lucian Bernhard out of the trenches to commandeer its poster effort. For the first time posters with a national rather than merely localized appeal came to public attention in Germany. As posters of all sorts began to emerge from all corners of the nation, the differences in style between north and south came to an end. The magazine *Das Plakat* (The Poster), which ran from 1909 to 1921, brought further consciousness of the *gebrauchsgraphik* to a national and international audience.

After the war, and after Germany's period of hyperinflation had ended, the poster industry tried to pick up where it had left off. It was 1924. The relatively stable Weimar Republic

Above, the consumate German gebrauchsgrafiker *(commercial artist), Prof. O.H.W. Hadank, didn't stop at advertising and trademark design. His complete corporate identity package even included the company's vehicles, 1925.*

was in place, and the economically promising years of the golden twenties began. Industrialization and mass production advanced rapidly. Goods were produced to be sold nationwide instead of locally. Competition among manufacturers became increasingly fierce.

As advertisers began to appropriate more of their budgets to national magazine and newspaper advertising the poster, once the primary venue of publicity, began to go into decline. A new advertising medium, the *prospektus* (a small brochure, pamphlet, or leaflet) took the place of the poster. Trademarks so popular with advertisers were well suited to this small-space advertising because essentially their function—like that of the poster—is to convey a direct message, simply and immediately. Of course, posters were not phased out entirely, but the reduction of the medium prompted *Gebrauchsgraphik* magazine to devote several entire issues in 1925 to appeals for its return.

THE END AND THE BEGINNING

1924 saw the creation of the *Bund Deutscher Gebrauchsgraphiker* (Alliance of German Graphic Artists). The association boasted over four hundred members, among them the best in the field. Few of their contemporaries in other countries enjoyed the celebration by the press of German and Austrian designers. Individual monographs trumpeting the talents of such designers as F. H. Ehmcke, Konrad Jochheim, Walter Kersting, Ludwig Hohlwein, and Julius Klinger were issued. German and Austrian designers' cooperation with industry was a proven success.

After World War II, the globalization of design trends began. In America, trends in "modern art" movements from Europe began steadily to infiltrate design, influenced in part by the powerful styles of such men as Bernhard, Binder, and Herbert Bayer, all of whom immigrated from Germany or Austria to America. Simpatico native designers such as Joseph Sinel, Paul Rand, and Lester Beals helped to firmly establish the roots of European design concepts in American soil.

Today, as ever, the work of German and Austrian designers is synonymous with fine design and innovative styling. The trends they have fostered in fine and graphic art, architecture, and crafts, as well as the typefaces they have produced, maintain their influence upon graphic designers the world over.

POSTERS

PLAKATE

THE ADVENT OF THE POSTER marks perhaps the most significant step in Germany's and Austria's ascension to worldwide fame in the graphic arts. Even the current terms "poster style" and "posterized" (which mean reducing a full tonal range to several flat values) can be attributed to the work of Ludwig Hohlwein, who gained fame with this technique. The international hoard of artists who copied Hohlwein were chided, "Mark how he coughs and spits, then imitate him and make your hits."

IN DISTINCT CONTRAST WITH HOHLWEIN, designers F. H. Ehmcke and Wilhelm Deffke used a sparse palette of entirely flat colors to give strength to their bold, simple posters. Julius Klinger, the "father of the Austrian poster," achieved a powerful effect in some cases with just black and white. One of Klinger's many students, Willy Wilrab, aped the master's sparse compositional sense, and his favorite lettering style, but added more complex tonality. Also from Austria, Josef Binder, like Klinger, utilized lots of white space instead of using color as a background framing device. In 1944 Binder became an American citizen. His technique helped inspire the American airbrush craze of the 1970s and 1980s.

THE HISTORY OF GERMAN POSTERS is one of continual refinement. Within a few years of the inception of the poster movement, the ultimate in simplicity was achieved: the concept of the poster as a "visual-byte" (like today's sound-byte) in the form of the poster stamp. A German invention, poster stamps soon spread to other countries and were widely collected. Some of the most popular German posters are shown here meticulously rendered in miniature.

ALONG WITH OTHER NOTABLE EUROPEAN POSTER ARTISTS, such as France's Cassandre, the German and Austrian designers had a profound effect upon American graphic artists, helping reform the way they viewed design. Their approach is as vital as it was seventy years ago, and their influence still keenly felt.

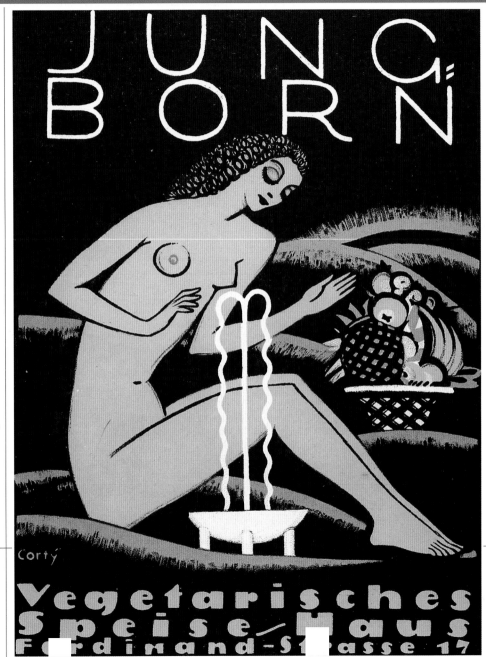

Design for the vegetarian restaurant Jung Born, 1919, by Dore Mönkemeyer Corty, the most prominent of Germany's female graphic artists.

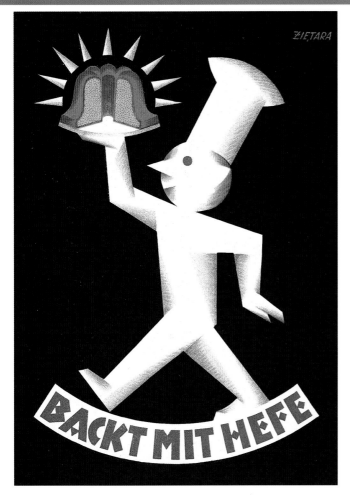

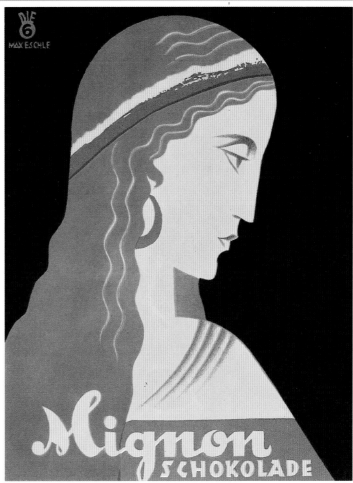

Above left, "Backt Mit Hefe" *(bake with yeast) by Valentin Zietara, the celebrated designer who headed up the group calling themselves* Die Sechs (The Six). *Another member, Max Eschle, produced the elegantly simple design, above right, for Mignon Schokolade (chocolate).*

23

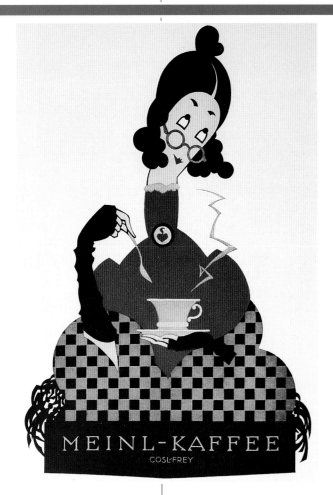

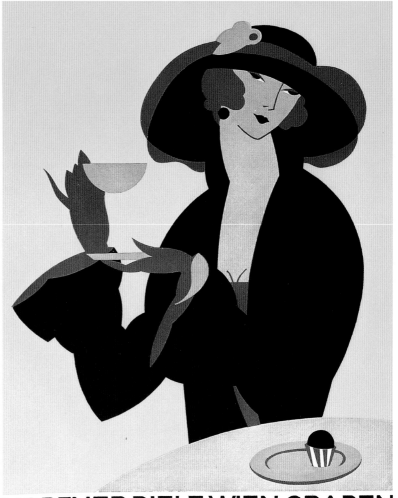

24

Above left, Meinl Kaffee (coffee), 1924, by Austrian artists Cosl-Frey is in direct contrast to their poster above, with an ultra modern fräulein *enjoying a break at the Hopfner Cafe, 1924.*

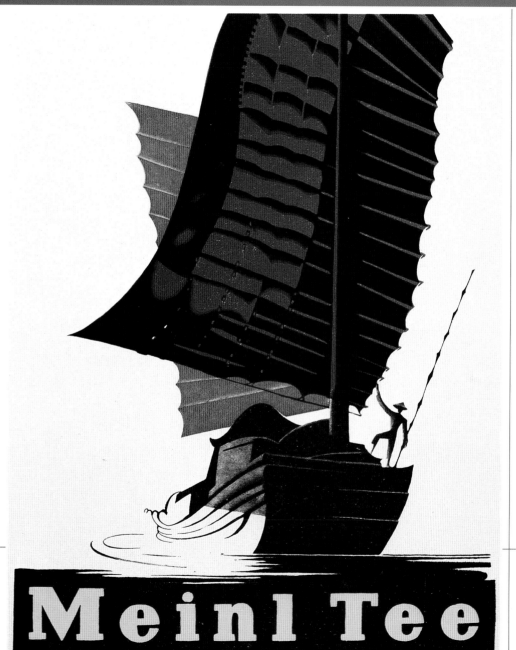

One of Joseph Binder's earliest posters, *Meinl Tee (tea)*, 1924, is in the Austrian manner yet offers a hint of this artist's own developing personal style.

The sure handling of the watercolor brush in this stylized yet realistic poster for Friemann Kaffee (coffee), c. 1927, is typical of Ludwig Hohlwein's work. The model may have been a family member to judge from her frequent appearances in his work.

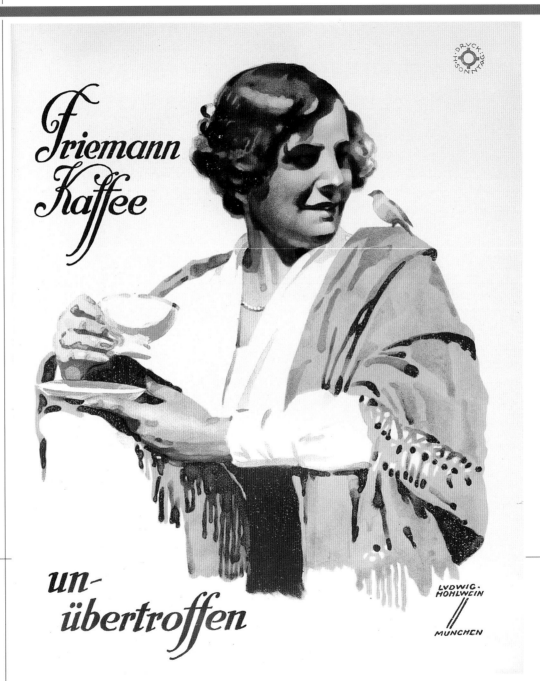

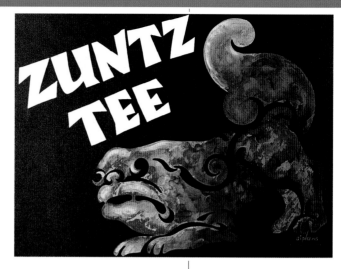

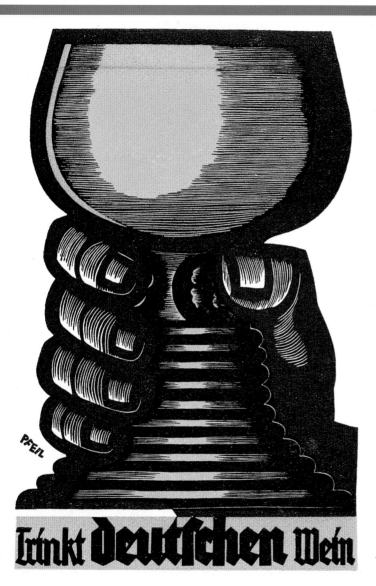

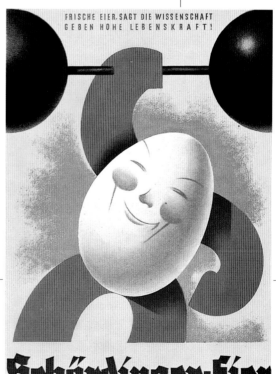

Above, Hartmuth Pfeil's "Drink German Wine," 1928, is
in an unusual poster style, resembling more his woodcut
book illustrations. Above right, Zuntz Tee (tea) by Julius
Gipkens, 1929. Right, poster for Schärdinger Eier (eggs) by
Lois Gaigg, 1934.

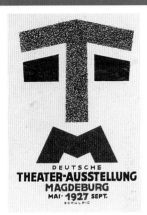

One of Karl Schulpig's most brilliant trademarks, shown on a poster stamp above, was that for the Theater Ausstellung (Exhibition in Magdeburg), 1927, in which the initials form a mask. Right, Schulpig's dramatic design for a 1925 conference of German concrete engineers.

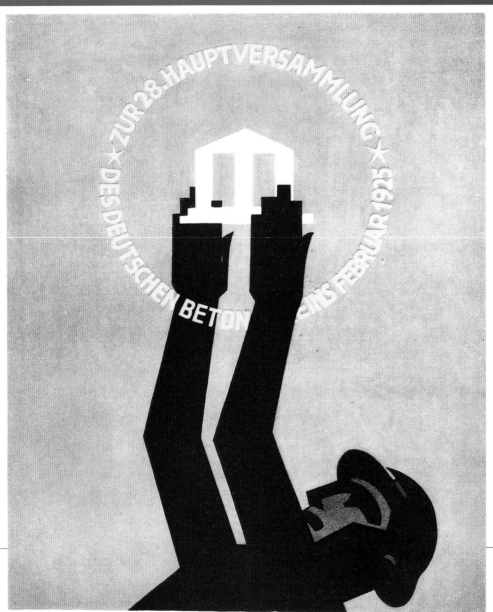

Poster stamps for exhibitions, such as the Bauausstellung (Construction Exhibition), 1925, and Leipziger Messe (fair) were as plentiful as these frequent exhibitions, which seem to have been much more popular in Germany than elsewhere.

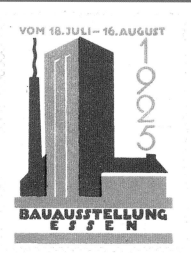

Left, a striking design by Wilhelm Deffke for the Deutsche Werkbund Ausstellung (German Workshop Exhibition), 1914.

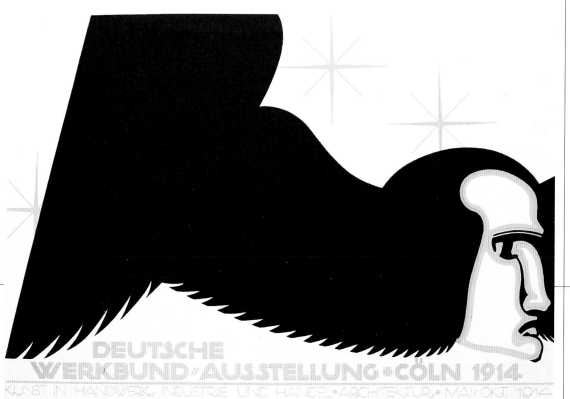

29

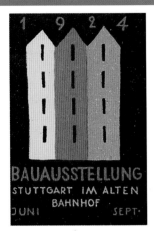

This poster stamp for the 1924 Bauausstellung (Construction Exhibition) in Stuttgart made effective use of primary colors.

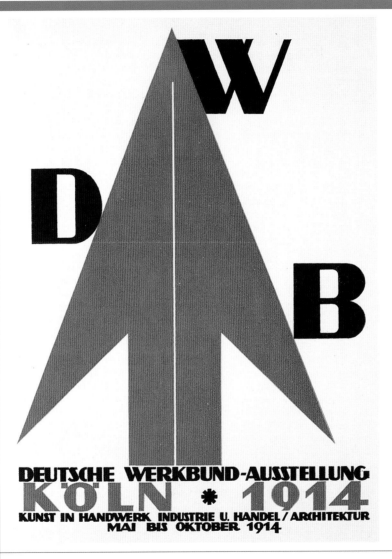

If the French invented art deco in 1925 nobody told Wilhelm Deffke, whose design, left, for the Deutsche Werkbund Ausstellung (German Workshop Exhibition) anticipated deco by over ten years. Below, Ludwig Hohlwein's poster for the Wach & Schliess Gesellschaft looked great reduced to poster stamp size.

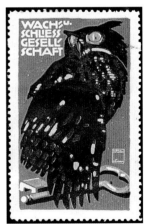

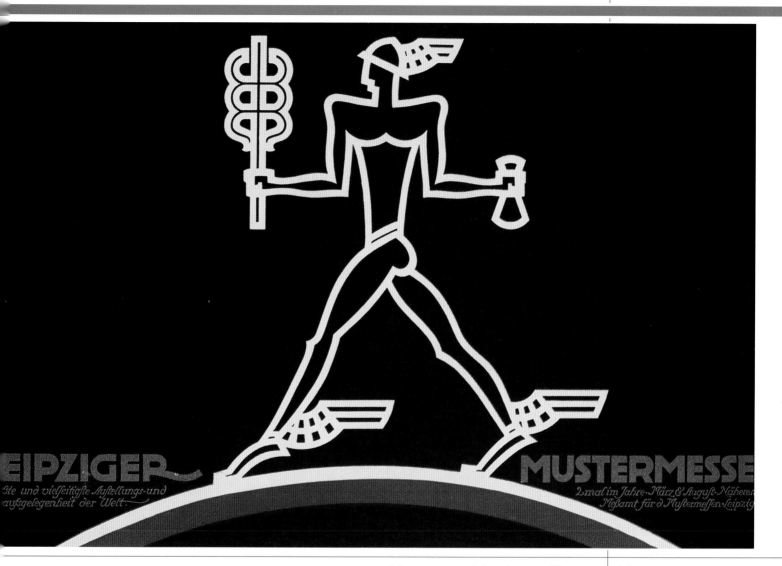

Above, a powerful and uncannily modern-looking design by Wilhelm Deffke for Leipziger Mustermesse, a tradeshow exhibiting new designs and inventions, 1920.

31

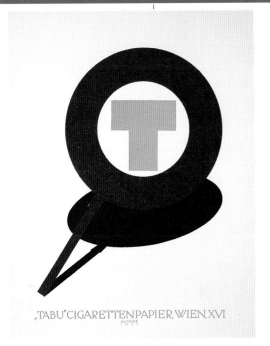

„TABU" CIGARETTENPAPIER, WIEN, XVI

Klinger's genius for simplicity is demonstrated in this poster, above, for Tabu cigarette papers. Right, Joseph Binder's trio of Turks enjoy Jyldis's brands of tobacco in a bold departure from the usual white background of Austrian posters.

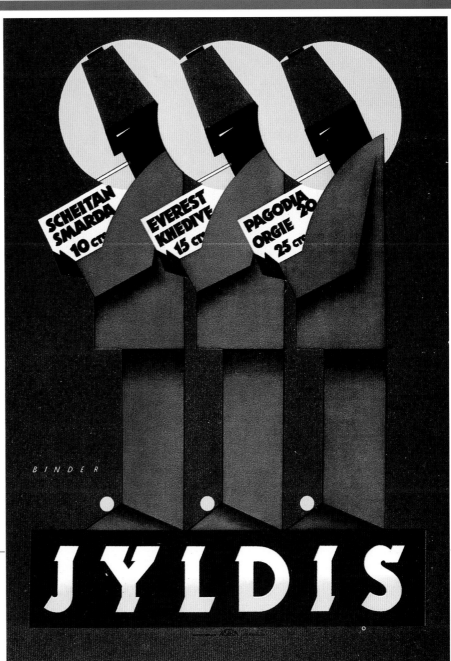

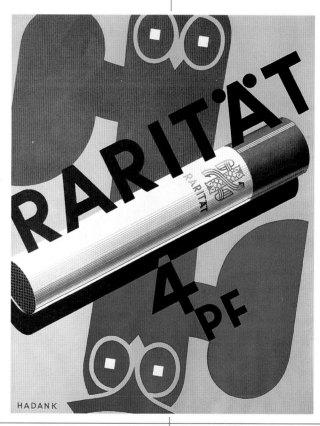

The absence of O. H. W. Hadank's usual ornate detailing in these cigarette posters for Haus Neuerberg, 1925, suggests that the designer is consciously trying out a more modern suit of clothes.

33

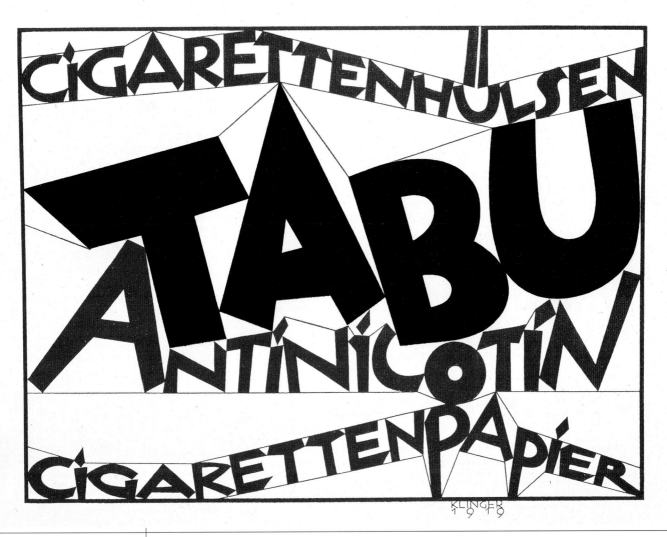

34

A stream of consciousness design by
Julius Klinger for Tabu, the cigarette
paper that promised to reduce
nicotine intake, 1919.

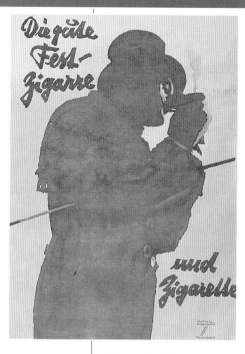

Cigarette manufacturers like Joseph Feinhals kept designers like F. H. Ehmcke busy making posters like these, c. 1921.

Above, Ludwig Hohlwein's design for "The good, festive cigar and cigarette" conjures an effective mood in a poster of timeless elegance.

35

*Above, design by Wilhelm Deffke for
Allgemeine Elektrizitäts Gesellschaft
(General Electric Company). Right,
Austrian designer Willy Willrab's
design for Teppichhaus Repper, a
carpet manufacturer.*

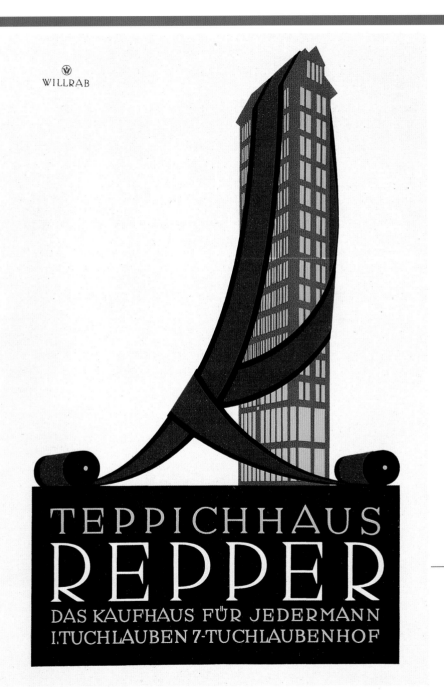

IV. WIENER BÜRO-AUSSTELLUNG
22.-30. SEPTEMBER 1923 MESSEPALAST 9-6 UHR

Design by Willy Willrab for IV. Wiener Büro Austellung (Fourth Viennese Office Exhibition), 1923, in his characteristic immaculate style.

37

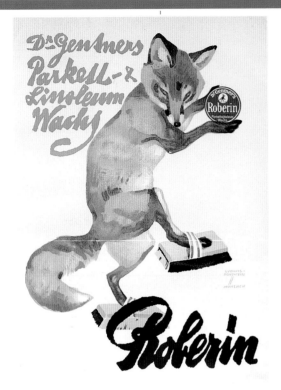

Two Hohlwein posters show how different engraving artists interpreted the master's style. Above, designs for Roberin, a floor polish, and right, for Haueisen & Sohn, makers of farming equipment.

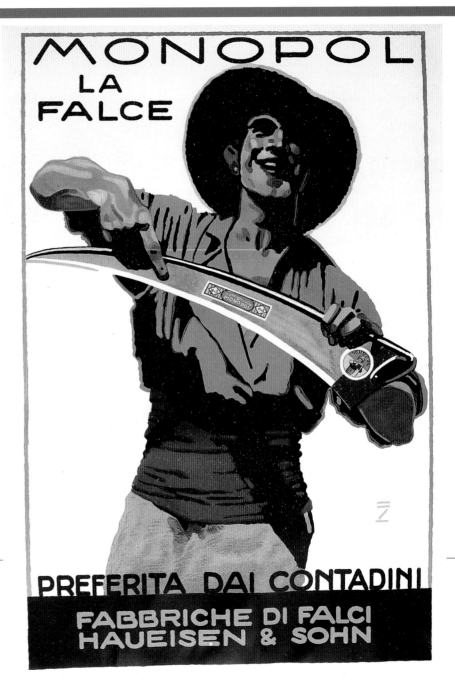

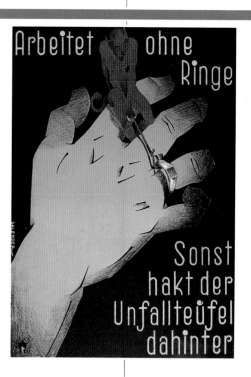

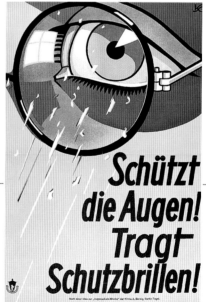

DONAU
ALLGEMEINE VERSICHERUNGS - A.G.

Above, Joseph Binder's airbrush style seen in this 1934 poster for Donau (an insurance company) was widely imitated. Top right, "Work without rings or the accident devil will hook you," warns this safety poster by Fritz Salender. Right, another poster, signed KS, admonishes, "Protect the eyes."

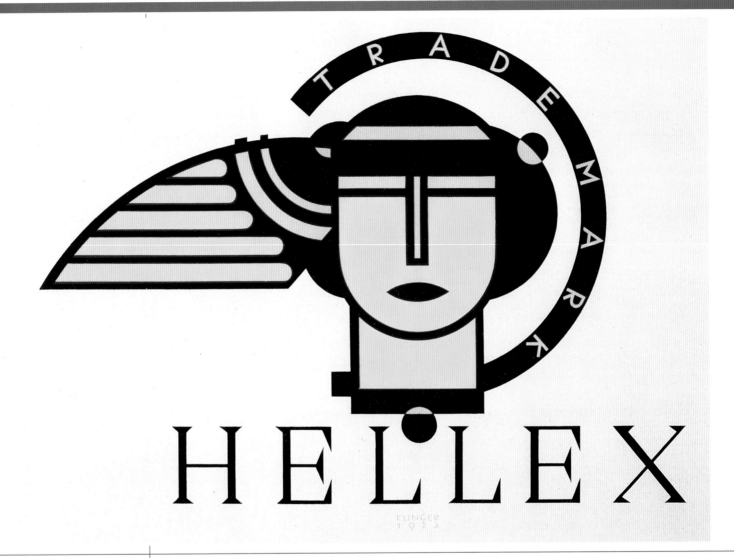

40 *Design by Julius Klinger for Hellex, possibly a British*
or American company since the word trademark is
in English. Austrian designers admitted to having
been huge fans of American culture and avidly sought
commissions from overseas.

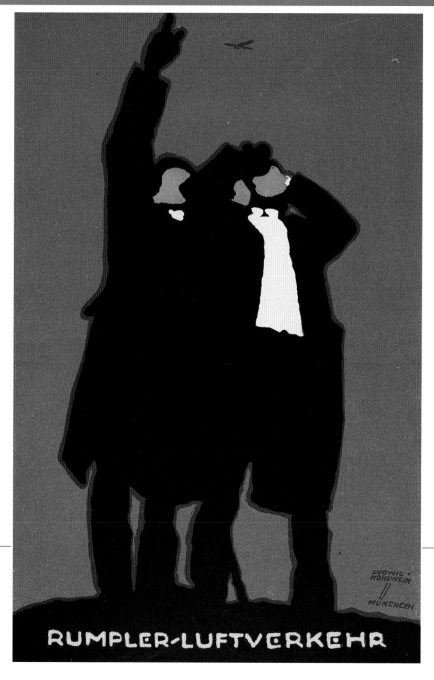

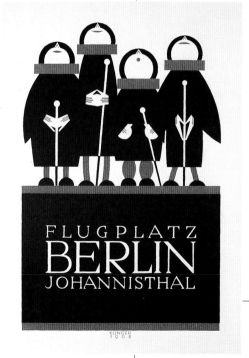

Far left, a Hohlwein design for Rumpler air traffic. Left, and below, a poster stamp and the original poster of a Klinger design for Flugplatz Berlin (Berlin Airport).

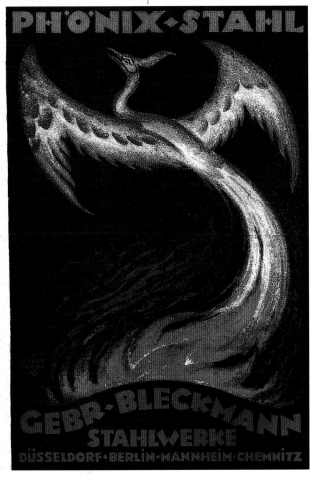

In this powerful poster by Mayer Lukas, the Phoenix rises from the fiery furnaces of Bleckmann Bros. Steel Works, 1929.

42

Wilhelm Deffke's war baby wrestles the empire's enemies in this appeal for bond subscriptions during World War I, c. 1916.

Above, in Wilhelm Deffke's economical composition for a town council meeting, 1920, the old city is shown in contrast with the growth of the new.

Left, a stylized image, unusual for Ludwig Hohlwein, forms a dynamic poster for Hermann Sonntag & Co., (lithographers), c. 1928.

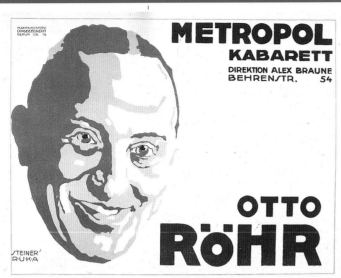

Apollo himself is the guiding spirit of the "Light-play house" or motion picture theatre, 1929, by Mayer Lukas. The softly glowing textural quality of the poster suggests the magic of this relatively new art form.

Above, a cabaret poster by Jo Steiner, 1919, shows a "consumer version" of Hohlwein's poster technique. Right, a film poster in extremely modern style by Jan Tschichold, 1935.

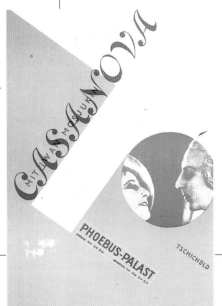

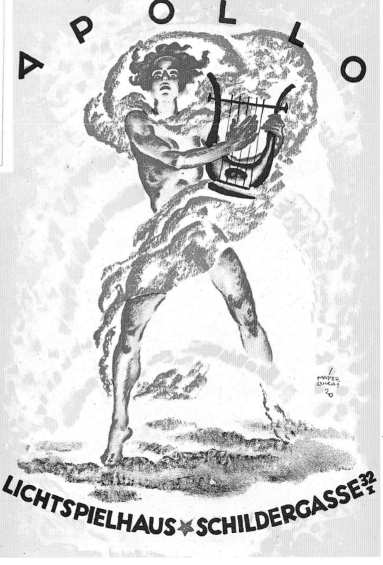

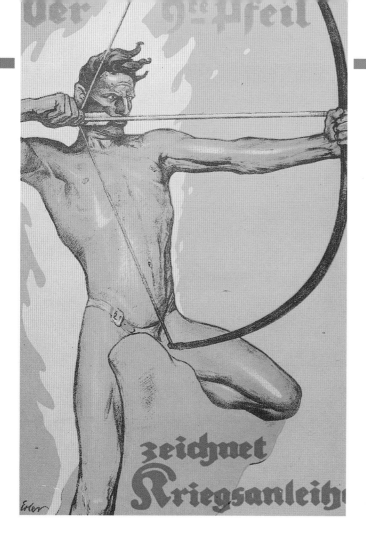

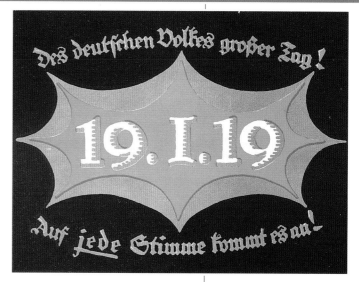

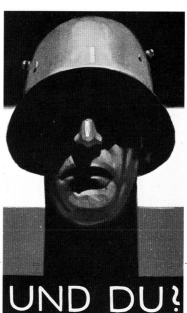

Above, "The 9th Arrow," designed by Fritz Erler, referring to the ninth appeal for investors in war bonds is exceptional for its fine drawing and subtle technique, c. 1917.

Above, "The German Nation's Big Day.... Every Vote Counts" an election poster by Ludwig Bernhard urged the vote in a precarious period following the war. Left, "And You?" asks this poster by Ludwig Hohlwein which would have been most politically correct in 1935.

45

PACKAGING

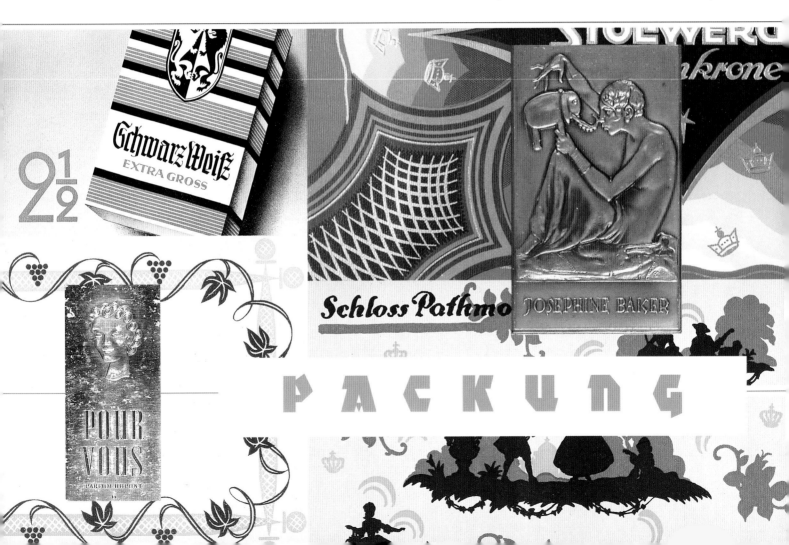

SOME OF THE MOST LAVISH GERMAN DESIGN was reserved for packaging. After all, where but at the point of purchase is expensive printing better utilized? Glossy, multicolor illustrations of mouthwatering *konfitüre* (sweets), heroic ornamentation, and gold and silver foil stamping added immeasurably to product sales appeal.

TRAVELING THROUGH EUROPE one notices the changes in architectural styles from country to country (and how these different styles subtly blend near the borders). In Germany art nouveau and art deco are distinctly different from their equivalents in, for example, France, Belgium, and Spain. Similarly the Germans took the copperplate flourishes of the Victorian era and fashioned them in their own cultural mold. They tamed the ornamentation, modernizing it and simplifying it, yet maintained the character and opulence. Thus in German labeling we find the antecedents of our own "classical" style of wine and cigarette labeling. The work of celebrated *gebrauchsgraphiker* O. H. W. Hadank exemplifies such classic details.

HADANK'S WORK FOR CLIENTS including Haus Neuerberg and Halpaus was a model of cooperation between artist and manufacturer. Hadank was to corporate design what Hohlwein was to the poster. His versatility and the technical perfection of his line work and lettering, combined with a sense of history, made him one of Germany's most respected designers. His cigarette packaging designs achieved their objective of an almost heraldic pedigree within the market (which once claimed by a manufacturer is rarely challenged). The stylistic precedents fostered by Hadank's highly acclaimed packaging is carried on in American cigarette packaging of today, however anachronistic these packages now seem.

GRAPHISCHE WERKSTÄTTEN
GERHARDT & TELTOW-LEIPZIG

6

Above, the Germans were not inured to the appeal of French perfume, as this silver-embossed label by the Graphische Werkstätten demonstrates. The label is nicely set off by the drawing of the bottle in what appears to be fine self-promotion for the designers.

48

Right, though immortalized in this bronze-embossed perfume label, Josephine Baker, the American who became a French icon, was alternately wooed and booed by more conservative German audiences. The ad, c. 1927, is self-promotional for the embossing firm, Gerhardt & Teltow.

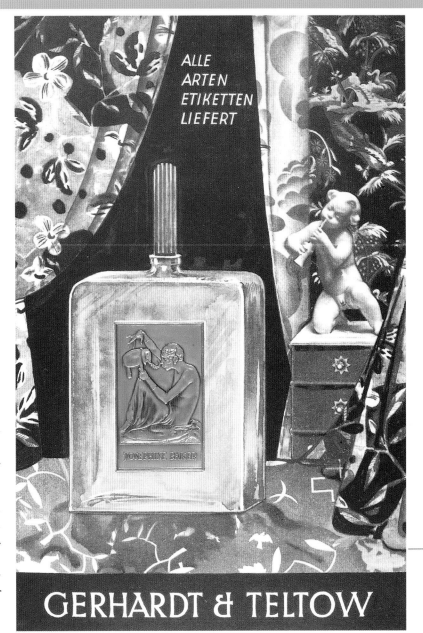

ALLE ARTEN ETIKETTEN LIEFERT

GERHARDT & TELTOW

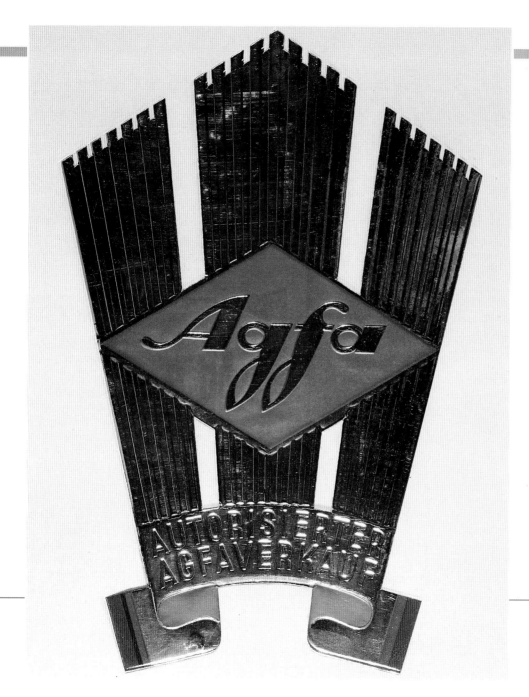

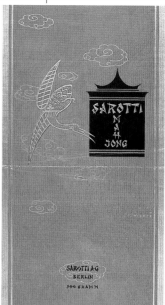

Left, this embossed, silver and gold foil emblem was hung in windows around 1927 to promote interest in Agfa film products. Above, the gold foil-stamped label designed by Julius Gipkens served well the exotic, oriental flavor of Sarotti Mah Jong konfitüre (sweets).

49

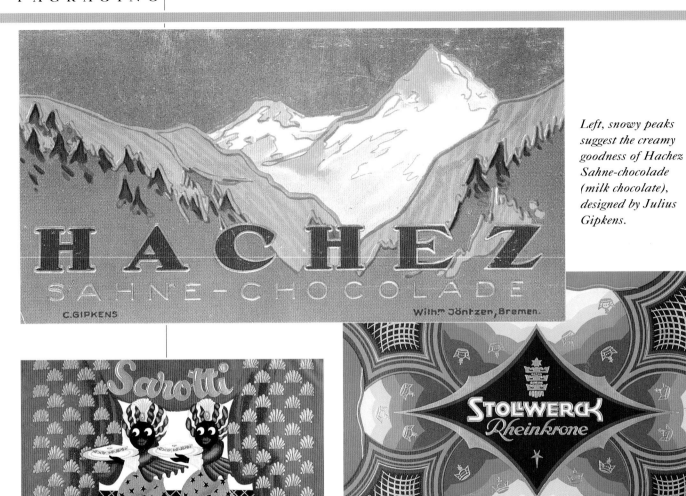

Left, snowy peaks suggest the creamy goodness of Hachez Sahne-chocolade (milk chocolate), designed by Julius Gipkens.

Above left, the packaging for Sarotti Zwei Mohren Milchung (pralines) is attractive in spite of the stereotypical stylization of the "two Moors." Above right, all the stops are pulled out in this elaborate design for Stollwerck Rheinkrone (a confectionery), 1927.

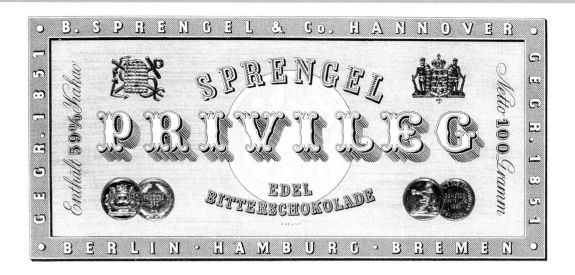

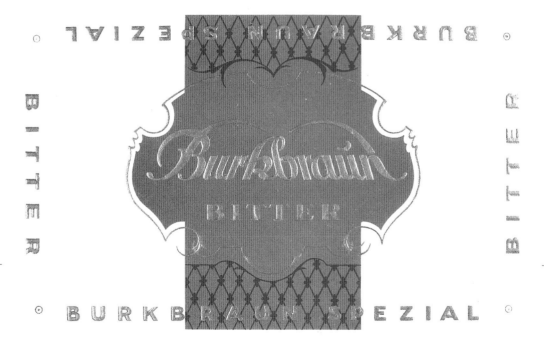

Above left, O. H. W. Hadank applies his midas touch to this packaging for Sprengel Privileg bitterschokolade (bittersweet chocolate). The firm's prizes and medals are stamped in gold foil. Left, a chocolate wrapping by Julius Gipkens for Burkbraun, 1926, which resembles contemporary packaging of European chocolates.

51

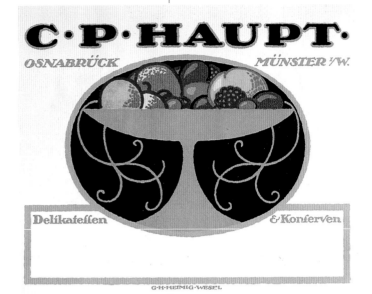

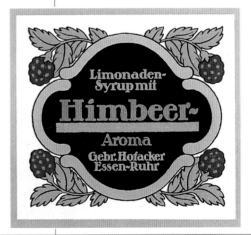

Above, the labeling of C. P. Haupt, 1915, is in the "warmer" old style of German design before Art Deco came into fashion.

52

Above, exotic, fruity combinations like this lemon syrup with raspberry aroma of Gebr. Hofacker has always had a special appeal for Germans, who must import many of these flavors.

Above, demonstrating printing inks of Krause & Baumann Co. called for the creation of these hypothetical "modern style" packaging labels, 1927.

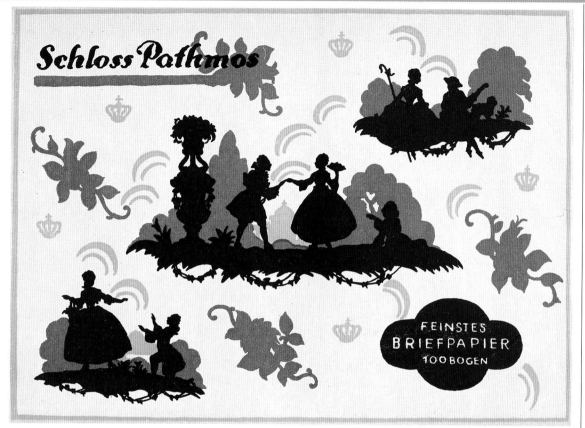

Left, designer Adelheid Schimz's packaging for Schloss Patmos—feinstes briefpapier (Castle of Patmos—fine letter stationery), 1919, carries forward the tradition of German cut paper silhouettes.

Right and below, packaging for ATO, a manufacturer of lettering pens, was bright and attractive, with a bold outlining, probably accomplished with the company's product. Pens such as these are employed in the writing of the Gothic blackletter scripts.

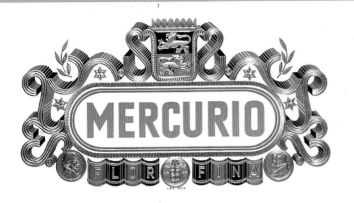

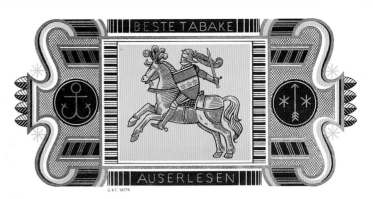

Above, classic cigar labels—German style—display rich, gold-embossed stamping, and fine detailing of the sort that O. H. W. Hadank made famous. However, these anonymous works from 1935 pale in comparison to those of the master. Right, the cigar packaging design by Adelheid Schimz for Phyllis, 1919, creates a subdued elegance despite a lack of ostentation.

54

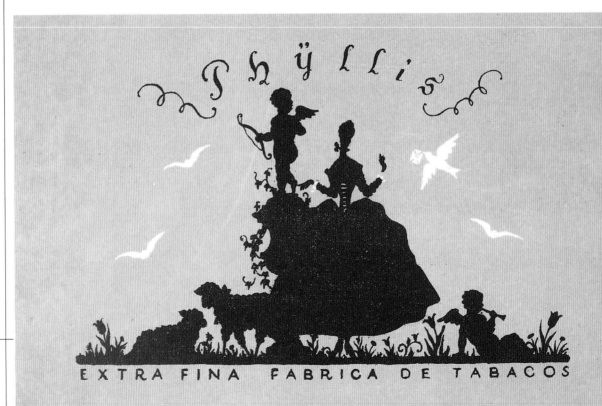

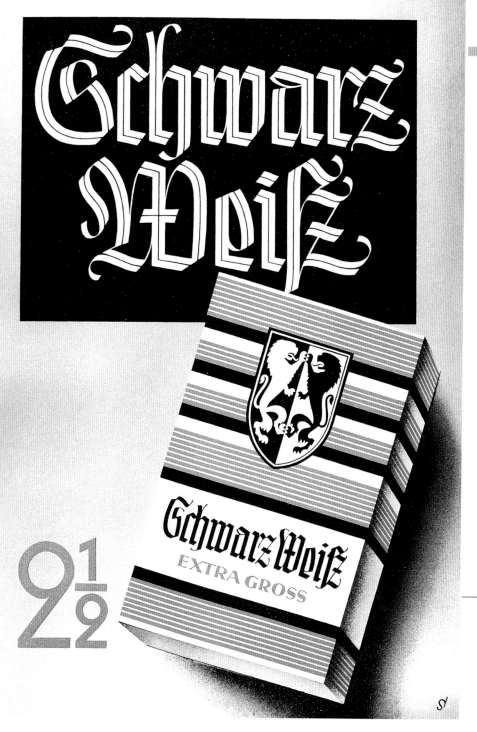

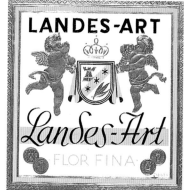

LANDES-ART

Landes-Art

FLOR FINA

Above, a company so good they named it twice, and to prove it, Landes-Art added golden cherubs and medals, 1935. Left, advertisement for Schwarz Weiss (Black White) cigarettes by Walter Spiegel, 1936, shows an approach that is modern yet not avant-garde. This is mainstream design of the period.

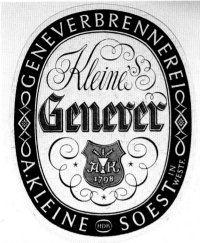

k: Gebr. Klingenberg, Detmold

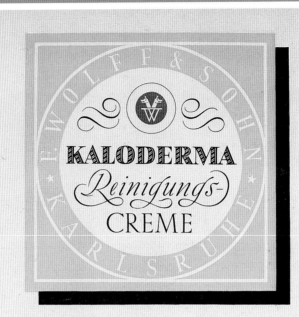

A wine label for A. Kleine, above, and packaging for F. Wolff & Sohne's Kaloderma (cold cream) by O. H.W. Hadank, c. 1939. Note how often Hadank's own signature logo appears on his designs: how unthinkable in today's package designs.

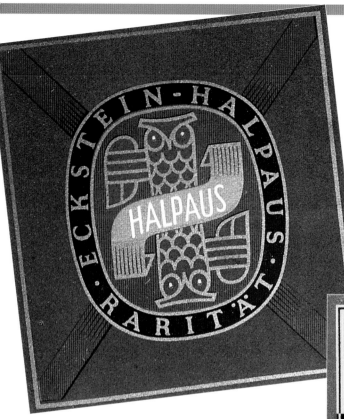

In cigarette packaging by O. H. W. Hadank, 1925-1937, every aspect of these designs is exquisite, not to mention remarkable for the period.

TRADEMARKS

SCHUTZMARKEN

THE OLD CUSTOM OF EMBELLISHING A KNIGHT'S EVERY IMPLEMENT, from tools and weaponry to clothing and armor, was carried forward by the Germans into modern advertising. As celebrated trademark designer Wilhelm Deffke explained in 1929, "Trademarks acquire their real worth and significance only through adequate usage. It is not sufficient to use them once in awhile to designate certain products. They must be used systematically and frequently on all means of advertising. The trademark will be the most likely to establish an inseparable bond between the user and the manufacturer." Indeed, from advertising (whose chief feature, often, was the trademark itself) to letterheads, and to building and delivery van signage and monumental tradeshow exhibition stands, the Germans proudly displayed their modern mercantile heraldry in a manner unrivaled by other countries.

IN TRADEMARK DESIGN OF THIS PERIOD the Germans had no peer. Their *schutzmarken* were an extension of the monograms, signets, and crests of their ancestors; from the great tradition of printers' signets came some of the first real commercial trademarks.

AS IN THE OLD, CLASSIC SIGNETS, many of the newer trademarks shown in this book display angelic cherubs, mythological creatures, and monogrammatic arrangements of the company initials. Here the similarity to the old ends. The outstanding achievements of these modern trademarks are strong design, simplicity of execution—compared with the complex scrolls and flourishes typical of the old marks—and brilliance of conception. Though some designs appear wonderfully dated, many others could have been created yesterday. With their geometric symmetry and sharp angles many of these trademarks would lend themselves perfectly to computer execution.

THE DESIGNERS OF THIS MODERN HERALDRY have not been consigned to ignominy. Most of the examples here are credited to their creators. (A number of other trademarks are unidentified; for all the designs included, credits and dates appear to the extent possible.) While American trademarks of this period—for all their charm—consisted largely of corny characters and imagery, the German trademark pointed the way to the future.

Animals

*J. Ehlers, designer
for unknown
company, 1928.*

*Peter Wolbrand,
designer for unknown
company, 1931.*

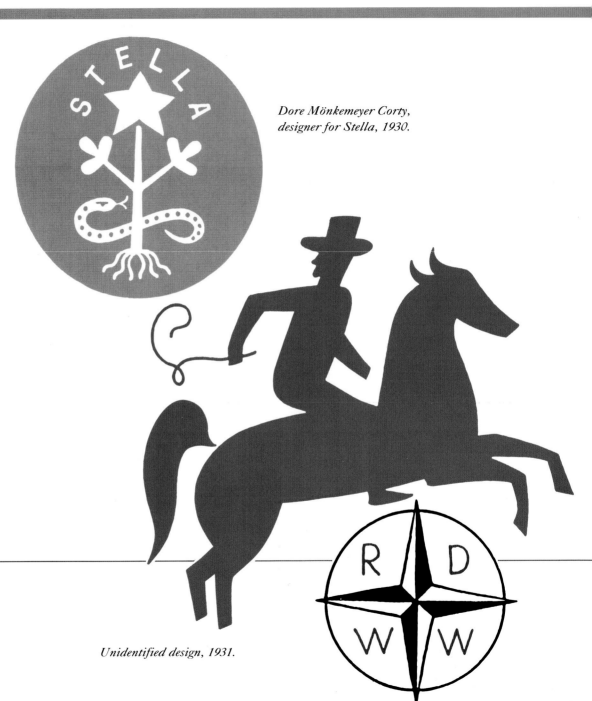

*Dore Mönkemeyer Corty,
designer for Stella, 1930.*

Unidentified design, 1931.

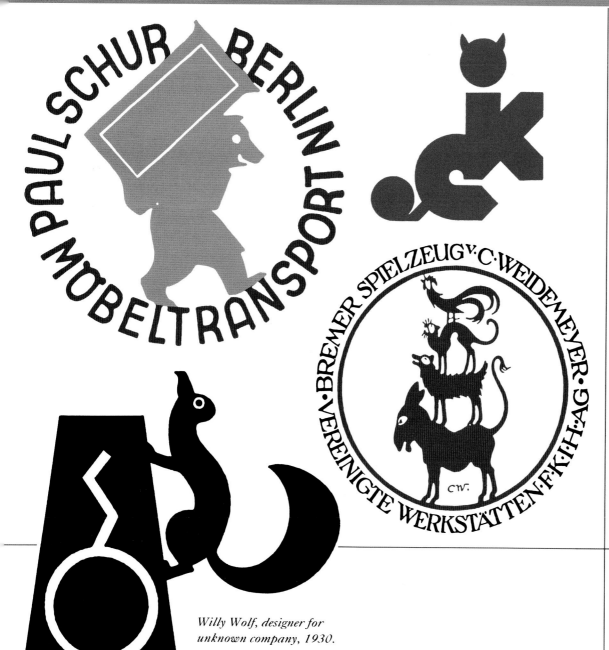

PAUL SCHUR · BERLIN · MÖBELTRANSPORT

BREMER SPIELZEUG v. C. WEIDEMEYER · VEREINIGTE WERKSTÄTTEN · F·K·I·H·A·G·

CW.

Far left, unknown
designer for Paul Schur
furniture movers. Left,
Martin Weinberg,
designer for unknown
company, 1926.

C. Weidemeyer,
designer for Vereinigte
Werkstätten (United
Workshop), 1925.

61

Willy Wolf, designer for
unknown company, 1930.

Animals

*Mayer Lukas,
designer for Jomsta Co.,
1920.*

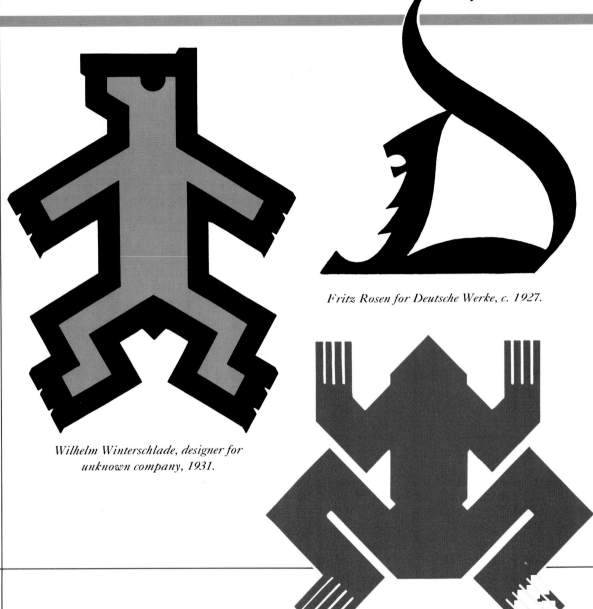

*Wilhelm Winterschlade, designer for
unknown company, 1931.*

Fritz Rosen for Deutsche Werke, c. 1927.

*Wilhelm Winterschlade, designer for
unknown company, 1931.*

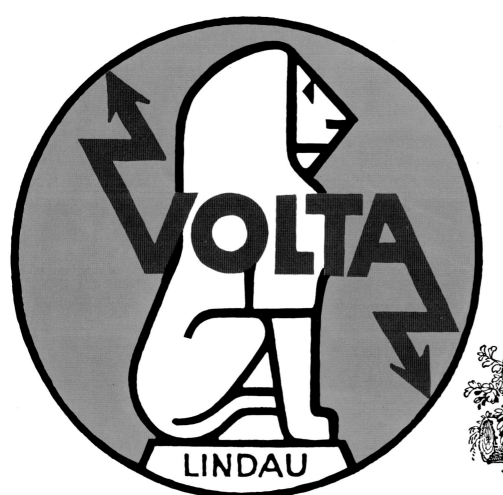

Mayer Lukas,
designer for Jomsta Co.,
1920.

Unknown designer
for Lindau company,
1929.

Unknown designer for
Breitkopf & Härtel Co.
(a printing firm), c. 1890.

Beasts & Birds

*F. H. Ehmcke,
designer for Einhorn
Verlag (a publisher),
1914.*

*Above left, Wilhelm Deffke,
designer for Silberstein &
Neumann (shoes), 1918. Above
right, Mayer Lukas, designer
for unknown company, 1920.
Left, Martin Weinberg,
designer for unknown
company, 1926.*

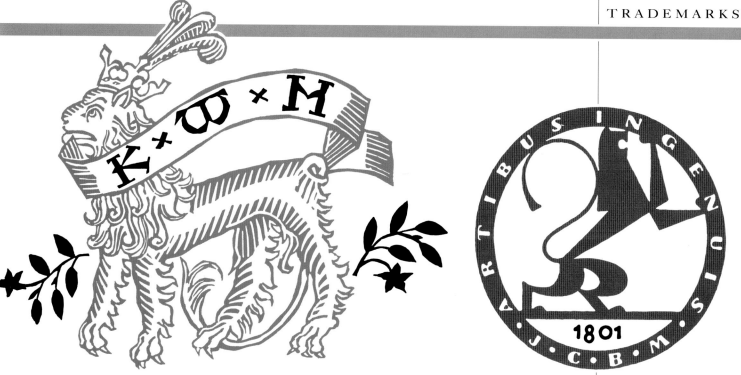

Above left, Erich Gruner, woodcut design for Karl W. Hiersemann Verlag (a publisher), 1917. Above right, H. Laupp'sche for J. C. B. Mohr (a book handler) c. 1929.

Left, unknown designer, for Pickenhahn Co., c. 1929.

65

Birds

Unknown designer for
Deutscher Verlag
Druckerei (German
publishers and printers).

Wilhelm Winterschlade for Berger &
Wirth (printing inks), 1936.

66

Top, unknown designer for
Berger & Wirth (printing inks).
Above, Jochem Bartsch, designer
for Deutscher Akademischer
Eingetragener (an academic
mover), 1934.

Alfred Resch, designer for Olga Vom Hagen, 1927.

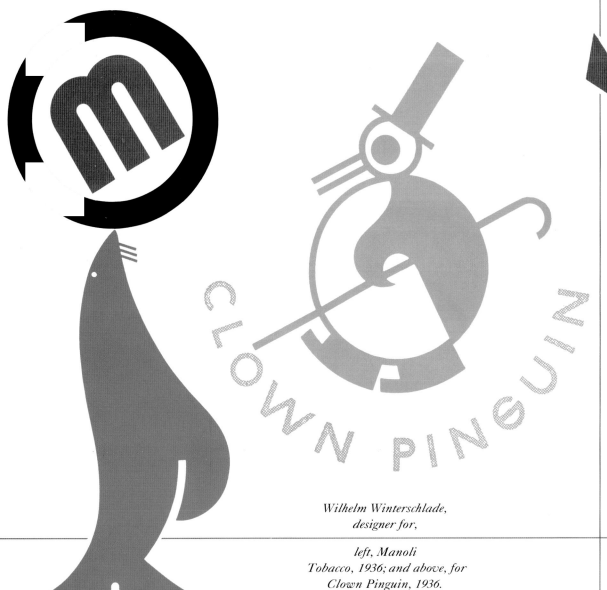

Ernst Heingenmoser,
designer for unknown
company, c. 1927.

Wilhelm Winterschlade,
designer for,

left, Manoli
Tobacco, 1936; and above, for
Clown Pinguin, 1936.

Mayer Lukas,
designer for
unknown company,
1920.

Birds

*Erich Gruner,
designer for Alfred
Hahns Verlag
(a publisher), c. 1924.*

*Wilhelm Winterschlade,
designer for unknown
company, 1936.*

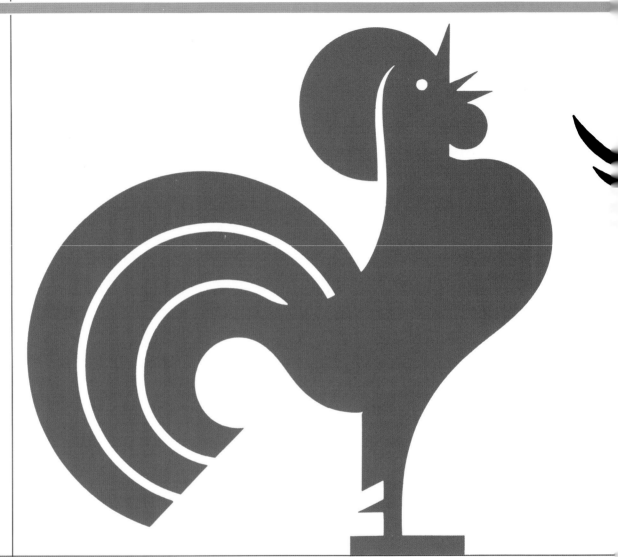

*Wilhelm Winterschlade,
designer for unknown
company, 1936.*

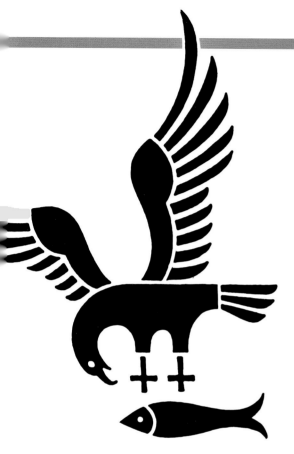

Hans Ernst, designer
for Rietzschel, 1938.

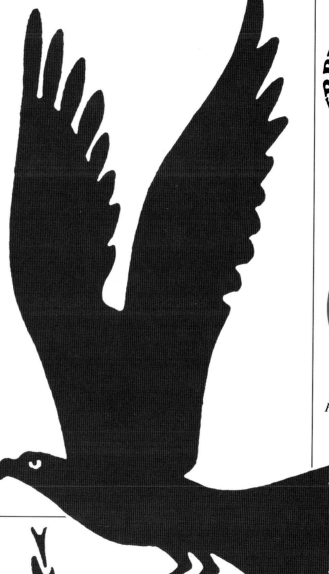

Designer unknown, for Deutsche
Luftkriegsbeute Austellung (German
Aerial Warfare Booty Exhibition), 1918.

F. H. Ehmcke, designer
for Basiler Buecher
Stube (a bookstore),
1919.

Designer unknown, for
Papierfabrik Scheeufelen
(a paper factory),
c. 1936.

Eagles

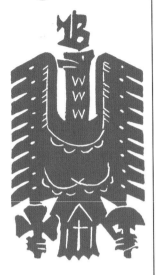

*Alfons Niemann,
designer for
Künstgewerbeschule
(a commercial art
school), 1922.*

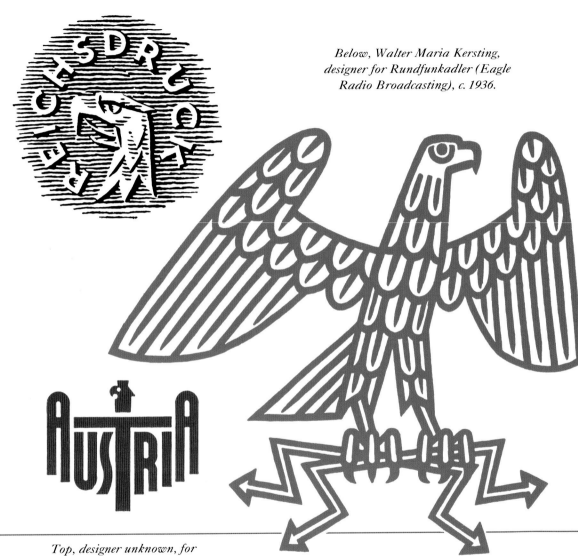

*Below, Walter Maria Kersting,
designer for Rundfunkadler (Eagle
Radio Broadcasting), c. 1936.*

*Top, designer unknown, for
Reichsdruckerei (the government
printer) c. 1929.
Above, Viktor Weixler,
designer for Austria (its tourist
bureau), 1935.*

Right, unknown designer, for Reichsdruckerei (the government printer), c. 1929.

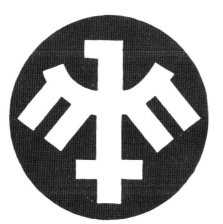

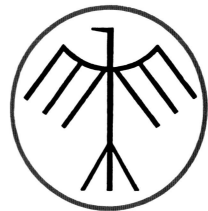

Gotthardt & Ehrlich, designers for Weiss & Lingmann (possibly a medical firm), 1927.

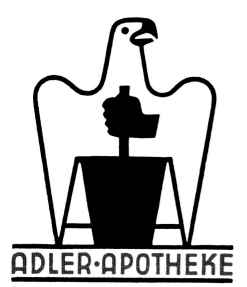

ADLER·APOTHEKE

Left, Erich Gruner, designer of woodcut signet for Verlag Karl W. Hiersemann (a publisher), 1919.

Above, Albert Heim, designer for Adler Apotheke (a pharmacy— Adler means eagle), 1927.

People

Peter Wolbrand,
designer for unknown
company, 1931.

Top center, Georg
Hommola, designer for
Alca (maker of glass
displays), 1919. Top
far right, Herbert
Bartholomäus, designer
for Die Hanse (tobacco
importer), 1938.

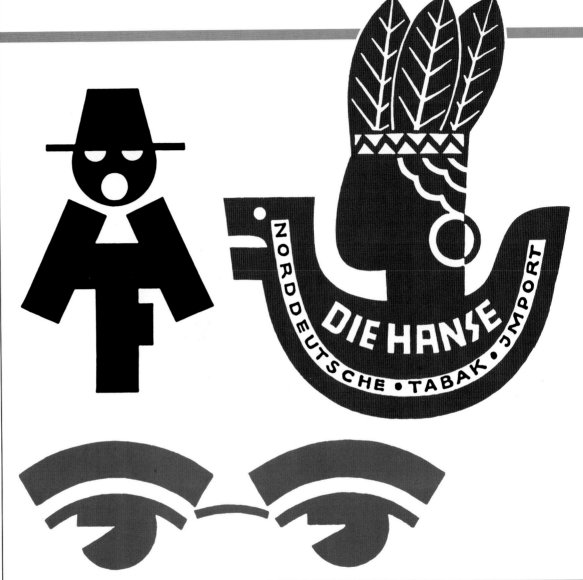

NORDDEUTSCHE • TABAK • JMPORT

DIE HANSE

72

Right,
Georg Wagner,
designer for unknown
company, 1926.

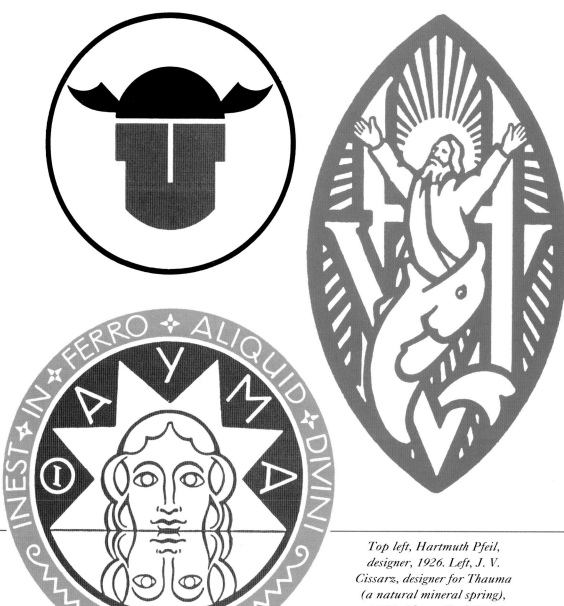

*Walter Reimer,
designer for Mitglied
des Bundes deutscher
Friseure (member of
the union of German
hairdressers), 1930.*

*Top left, Hartmuth Pfeil,
designer, 1926. Left, J. V.
Cissarz, designer for Thauma
(a natural mineral spring),
c. 1928. Above, Karl Kästen,
designer for Herder & Company
(a religious publisher), 1929.*

People

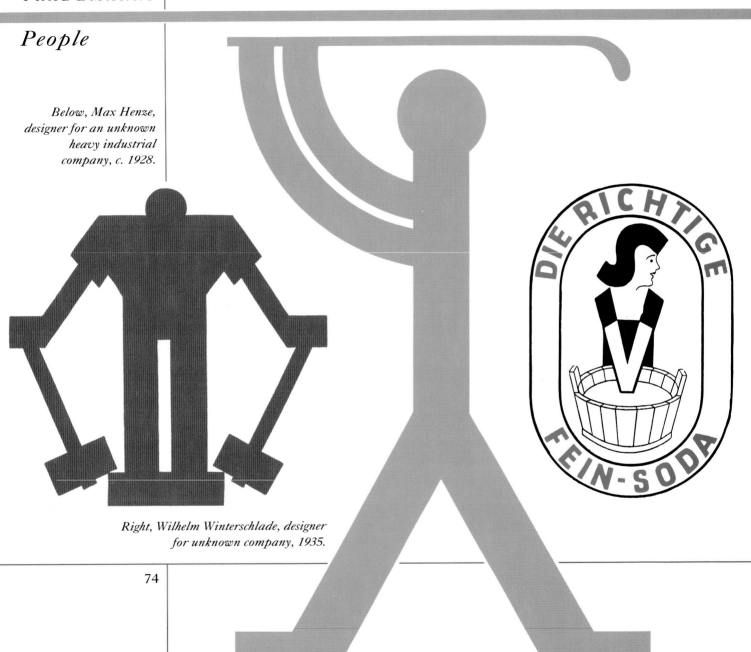

Below, Max Henze,
designer for an unknown
heavy industrial
company, c. 1928.

Right, Wilhelm Winterschlade, designer
for unknown company, 1935.

DIE RICHTIGE
FEIN-SODA

74

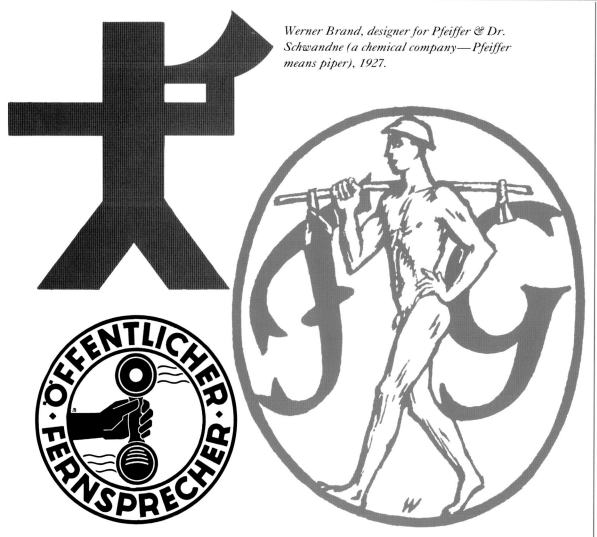

Werner Brand, designer for Pfeiffer & Dr. Schwandne (a chemical company—Pfeiffer means piper), 1927.

Above, unknown designer, for Öffentlicher Fernsprecher, (a public telephone symbol), 1928.

Above, R. Weiss, designer for Fritz Grunlicht (an art gallery), c. 1929.

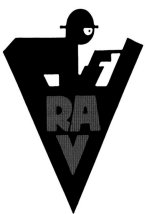

Above, unknown designer for JBV company.

Georg Hommola, designer for Reichs-adressbuch Verlag (a government directory publisher), 1924.

75

People

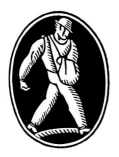

Paul A. Weber, designer for G. Grote'sche Verlag (a publisher), c. 1928.

Right, Gustav Müller, designer for Süddeutsche Polizeiruf (possibly a security company), 1930.

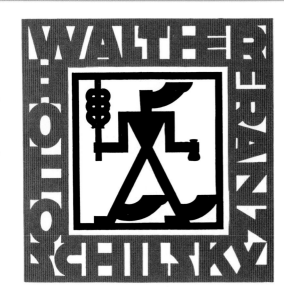

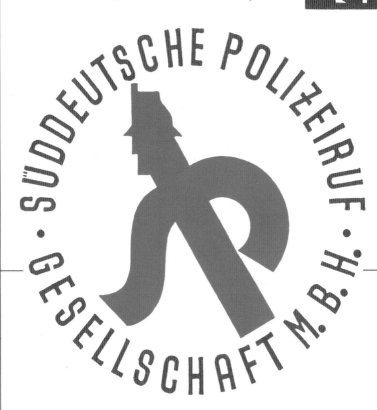

Top left, Walter Kersting, designer for Stahl *(a steel industry magazine), 1928. Top right, Wilhelm Deffke, for an unknown company, 1921. Above, Heinz Bötcher, signet for an unknown publisher.*

Cherubs

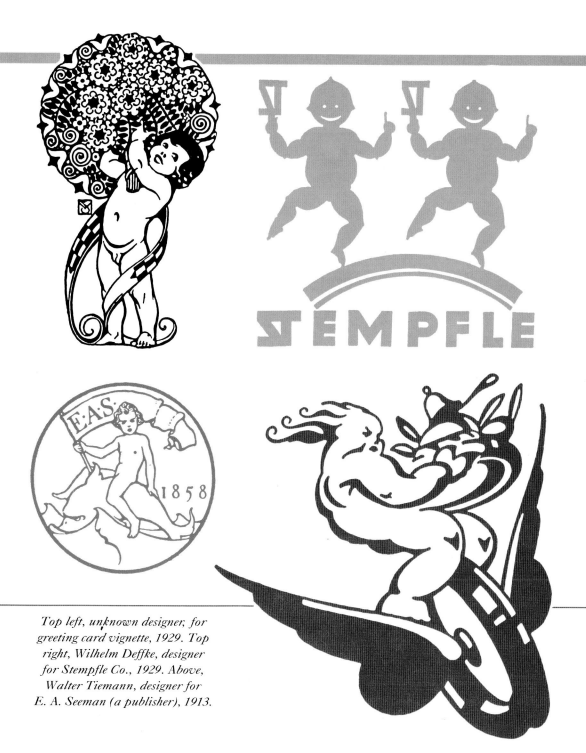

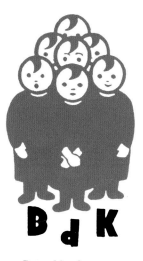

Dore Mönkemeyer-Corty, designer for Bund der Kinderreichen (association of "families rich in kids"), 1935.

Left, Dresden Design Workshop, designers for Beyer & Bergmann Co., c. 1930.

Top left, unknown designer, for greeting card vignette, 1929. Top right, Wilhelm Deffke, designer for Stempfle Co., 1929. Above, Walter Tiemann, designer for E. A. Seeman (a publisher), 1913.

77

Monograms

*Heinz Keune,
designer for
Kunstgewerbe und
Handwerkerschule
(a vocational school for
arts and crafts),
c. 1929.*

*Erich Gruner, designer's
personal mark, 1909.*

78

*Top left, J. Ehlers, designer
for unknown company, 1928.
Above, Erich Gruner, monogram
design, 1928. Right, Hartmuth
Pfeil, designer for Bäckerei Carl
Krämer (a bakery), 1926.*

Georg Hommola, designer's personal mark, 1923.

Left, F. H. Ehmcke, designer for Löwenbräu Brewery, 1922.

Top left, R. W. Groh, designer's personal mark for Groh Studio, c. 1930. Top right, Georg Hommola, designer for Anders Kartonagen Fabrik (a box and packing factory), 1925.

Monograms

Hans Möhring,
designer for
Rossberg'sche
Buchdruckerei
(a book printer),
1926.

*Right, Alfons
Niemann, designer for
Verlags Die Sterne ("the
stars publisher"), 1922.*

*Top left, designer unknown for Deutsch
Werkbund, 1912. Top right, Erich Gruner,
designer for Verlag des Leipziger Messants
(a publisher), 1917. Right, Oscar Berger,
designer for Cafe Berlin, c. 1927.*

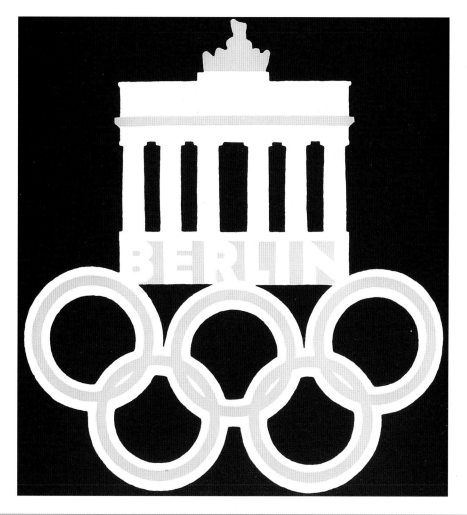

*Above left, Walter Maria Kersting, designer
for Berlin Olympics, 1936. Upper right,
Kersting, designer for Premier Schokolade
(chocolate), c. 1938. Right, Kersting for Wilke
Hutfabrik (a hat factory), c. 1939.*

THE LETTERHEADS IN THIS SECTION come mostly from the 1920s, yet many of them look current. In part this is due to today's designers having looked back to such work for inspiration. But it is also because German graphic artists of the 1920s were defining design aesthetics that would endure.

SANS-SERIF TYPEFACES, which generally were not accepted in America until the 1930s, contribute to the clean, modern feeling of many of these German examples. Blocky, Bauhaus-inspired type arrangements and ruled borders that create spaces for the recipient's address also add to the modern effect.

NOTABLE AS WELL IS THE PREPONDERANCE OF SOBER SYMMETRY and straight, unadorned type. Of course, the Gothic blackletter types are very much in evidence in some examples. They lend an unfamiliar, alien flavor not present in other period European designs. Use of the visually rich blackletter, so in keeping with the style of German graphic art, nevertheless declined in the ensuing years.

CONSIDERING THE LAVISHNESS OF SO MUCH PRINTING in this period, it is interesting that most of these letterhead designs appear rather modest. Some of Germany's finest designers, such as Philip Seitz, Karl Prinz, and Josef Binder, had letterheads of only two colors. *Gebrauchsgraphikers* Albert Rabenaur and Konrad Jochheim splurged on gold borders, but others, including the equally esteemed Bruno Paul and Theodor Hochreifer, made do with plain, black ink.

EVEN SOME PRINTING FIRMS, such as Klimsch's, Bronner's, and C. Dunnhaupt, had rather plain designs. To the Germans an extravagant letterhead may have equaled vulgarity. The seriousness of business correspondence is evidenced by the use of forgery protection devices, such as tinted areas in which letter dates and signatures were typed or officially stamped, as on a check or legal document. And of course, front and center, most of these letterheads feature the ubiquitous trademark.

WERBEABTEILUNG

J.G.SCHELTER & GIESECKE, LEIPZIG C1

SCHRIFTGIESSEREI UND DRUCKSTOCKANSTALT

BUCHDRUCKMASCHINENFABRIK DER „WINDSBRAUT" UND „PHÖNIX"

BRÜDERSTRASSE NR. 26—28 ● DRAHTANSCHRIFT: SELTERGIES LEIPZIG
FERNRUF-SAMMELNUMMER 70381 ● NACH DEM GESCHÄFTSSCHLUSS 19498

IHRE ZEICHEN IHRE NACHRICHT VOM UNSERE ZEICHEN TAG

BANK-KONTEN: REICHSBANK-NBST-GLAUCHAU
DRESDNER BANK, DRESDEN · ALLGEM· DEUTSCHE
CREDIT-ANSTALT, ABT· BECKER & CO·, LEIPZIG ·
POSTSCHECK-KONTO NR·: 460 LEIPZIG

8 PAPIERMASCHINEN MIT EINER TÄGLICHEN
ERZEUGUNG VON 70 000 KG · PAPIER
DRAHTNACHRICHTEN: PAPIERFABRIK PENIG
FERNSPRECHER: AMT PENIG NR·: 1/9 u. 28

Patentpapierfabrik zu Penig/Penig i·Sa·

Penig/den

84 *Top, a trio of type slugs used in letterpress printing (now almost completely obsolete) forms the trademark of J. G. Schelter & Giesecke, a manufacturer of type and printing equipment. Above, Penig, Penig, a manufacturer of banknote and check paper, used classic German blackletter "schrift" (type) for its logo and trademark.*

B D G

BUND DEUTSCHER
GEBRAUCHSGRAPHIKER E.V.
BUNDESLEITUNG

BDG BERLIN SW 48, WILHELMSTRASSE 37-38

FERNRUF: F5 BERGMANN 1791
POSTSCHECKKONTO: BERLIN NW 7, 684 27
BANKKONTO: DEUTSCHE BANK, DEP.- KASSE „PQ"
BERLIN SW 68

*Top, the BDG (Alliance of German Graphic Artists)
letterhead sported a trademark by Karl Schulpig that was
selected from among hundreds of contributions from the
organization's members. Above, like so many of these
examples, the letterhead of book printer Fischer &
Wittig was entirely hand lettered.*

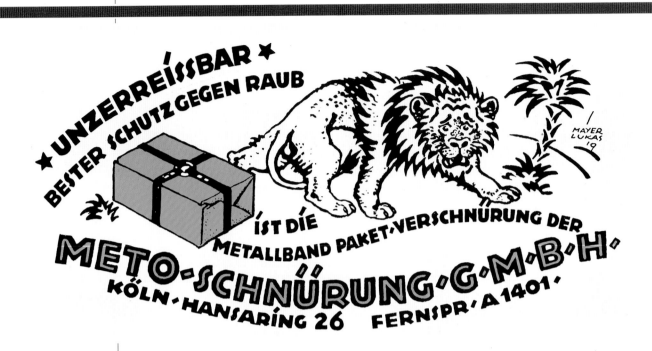

86 *Top, even the king of beasts is intimidated by the strength of Meto-Schnürung's metal straps in this amusing design by Mayer Lukas from 1919. Above, the woodcut craftsmanship of Theodor Hochreifer's design seems well suited to Rudolf Lang's bookbinding workshop.*

Top, in 1925, the year that the French introduced Art Deco to the world, German art deco was already in evidence, as Max Eschle's design for the "Exhibition of Bavarian Handicrafts" proves. Above, this design for C. Lisner & Söhne (producer of canned and pickled fish) is in four colors and features the sort of fat and wiggly lettering style popularized by Lucien Bernhard.

SPEZIAL-GEBIETE
SCHUTZMARKEN · KATALOGE · KALENDER · BRIEFBOGEN · WERBE-POSTKARTEN · GESCHÄFTSPAPIERE · BERATUNGEN UND TEXTE ALLER ART

SEITZ

REKLAMEKÜNSTLER UND WERBEBERATER
HAMBURG
ZEUGHAUSMARKT 33 / RUF: C 6, NIKOLAS 3304 / POSTSCHECK: HAMBURG 78127

WIENER GRAPHIK
TELEFON U-42-4-65 · POSTSCHECK-KONTO: 195.409
JOSEPH BINDER
WIEN · IV · BEZ

MÖLLWALDPL · 5

Top, Philip Seitz, an extremely prolific designer, didn't fail to mention any aspect of werbekunst (advertising art) in his list of specialties. Above, Joseph Binder's letterhead uses a distinctly personal lettering style, identical to that in his early posters, which is a variation on the standard lettering of Austrian posters.

VEREINIGTE ATELIERS FÜR WERBEKUNST

KUNSTMALER

HANS BEYER · PREUSSER
UND FRITZ GLASEMANN

GRAPHIKER B.D.G.

NIEDERNHAUSEN / TAUNUS / BEI FRANKFURT AM MAIN

KARL PRINZ

MALER UND
GRAPHIKER
BERLIN W 35
DERFFLINGER
STRASSE 22
TELEFON: B 2
LÜTZOW 3685

ENTWÜRFE FÜR PLAKATE PROSPEKTE KATALOGE INSERATE SCHUTZMARKEN BRIEFAUSSTATTUNGEN · ORIGINALGRAPHIK

IHR ZEICHEN	IHRE NACHRICHT VOM	KOMM.-NR.	DATUM

BETRIFFT

*Top, BPG, the studio of Hans Beyer-Preusser and
Fritz Glasemann, showed a marked Bauhaus influence
in its stationery design. Surrounding, Karl Prinz
defined space with a vertical line of type as a framing
device. The recipient's address was typed above the
horizontal line, and below that were referenced such
details as the date of the initial correspondence,
current date, and subject of the letter.*

ENTWÜRFE FÜR PLAKATE · PROSPEKTE · INSERATE USW. · ILLUSTRATION · WERBE-GEDICHTE UND PROSA-TEXTE

K-KONTO: FRANKFURT-MAIN NR. 27548 · DRAHT-ANSCHRIFT: BEYER NIEDERNHAUSENTAUNUS

HOFBUCHDRUCKEREI VON C. DÜNNHAUPT G·M·B·H· DESSAU
BUCHDRUCK · OFFSETDRUCK · ROTATIONSDRUCK · BUCHBINDEREI · ÄTZEREI

Telegr.-Adr.: Dünnhaupt Deſſau · Fernſpr.: Sammel-Nr.3106 · Bankkto.: Anhalt-Deſſauiſche Landesbank, Disconto-Geſellſchaft Filiale Deſſau
Reichsbank-Giro-Konto · Scheckkonto: Städtiſche Kreisſparkaſſe Deſſau, Konto 181 · Poſtſcheckkonto: Magdeburg Nr. 4052

Trierischer Volksfreund

HÖCHSTE AUFLAGE UNTER DEN
TAGESZEITUNGEN DES REGIERUNGS-
BEZIRKS TRIER. WEITAUS HÖCH-
STE STADTTRIERISCHE AUFLAGE

GEGRÜNDET 1875

90 | *Top, any gratuitous commentary is inadequate to describe
the simply great looking stationery for C. Dünnhaupt (printer).*
Below, Frierischer Volksfreund, *a newspaper, billed itself as
having the highest daily circulation (and a trademark by
Philip Seitz, whose own letterhead appears on p. 88).*

ERASMUS DRUCK
G M B H
BERLIN S 42
ALEXANDRINEN-
STRASSE
94

FERNSPR.: DÖNHOFF 2457-58, 5814-15
TEL.-ADR.: ERASMUSDRUCK BERLIN
CODES: A.B.C. 5TH U. 6TH, RUDOLF MOSSE

BANKKONTO: DISCONTO-GESELLSCHAFT
DEPOS.-KASSE ORANIENSTRASSE 139
POSTSCHECKKONTO: 60125 BERLIN

KLIMSCH'S
DRUCKEREI J. MAUBACH & CO · G · M · B · H
BUCHDRUCK + STEINDRUCK

TIEFDRUCK + OFFSETDRUCK
FERNSPRECH-ANSCHLUSS: AMT HANSA 7259-7261 **FRANKFURT A · M · BURGERSTRASSE 6 · DEN** 30. 8. 29.
TELEGRAMME: MAUBACHCOMP, FRANKFURTMAIN
·POSTSCHECK-KONTO: FRANKFURT-MAIN, NR. 2081

Top, Erasmus Druck's stationery design was simple and elegant but may have been considered far less modern than Klimsch's off-center type arrangement, which allowed the recipient's address to be typed in the center open area. The date was placed in the lower right corner, a seemingly unnecessary antiforgery device perhaps held over from an earlier tradition.

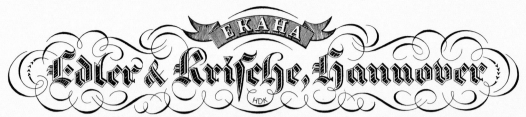

EKAHA

Edler & Krische, Hannover

GESCHÄFTSBÜCHERFABRIK ★ BUCH~& STEINDRUCKEREI

Niederlagen in allen großen
Städten des Deutschen Reiches
Zweigniederlassungen in
Berlin und Mannheim

Reichsbank~Giro~Konto
Postscheckkonto: Hannover 23
Drahtanschrift: „Ekaha"
Fernruf: Sammel~Nr. 5 21 61

Werbe-Abt. ➤ Hannover, den 9. Sept. 1929 ◀
Ca

GÜNTHER WAGNER

HANNOVER UND WIEN

FERNSPRECHER: 5 10 01
REICHSBANK-GIRO-KONTO
POSTSCHECKKONTO HANNOVER 456

TELEGRAMM-ADRESSE
PELIKAN-HANNOVER
KONTO 74 009 BEI DER HANNOV. BANK

A.B.C. CODE, 5. UND 6. AUSGABE / A¹ CODE / LIEBER'S STANDARD CODE / RUDOLF MOSSE CODE

92 | *Top, the unbelievably steady hand of O. H. W. Hadank is demonstrated again in this design for Edler & Krische, a book printer. Note the shaded date "protection" device. Above, unlike many of the now defunct companies represented in this book, Gunther Wagner's Pelikan brand art supplies are still available around the globe. The company's logo type style is more typical of the Vienna (Wien) style than of the German city, Hannover.*

SCHRIFTGIESSEREI
D. STEMPEL AKTIEN-GESELLSCHAFT
FRANKFURT AM MAIN · LEIPZIG · WIEN · BUDAPEST · BASEL

Schließfach: Nr. 1035. Telegramm-Adresse: Schriftstempel Frankfurtmain
Fernruf: Sammelnummer Spessart 60091. Bauers Code, Rudolf Mosse Code,
ABC-Code 5. Ed., Eigener Code. Postscheckkonto Frankfurt am Main Nr. 216

FRANKFURT A. M.–SÜD 10, den

G R A F I K E R

T Y P O G R A F

HERMANN SCHLAMELCHER ● MÜNCHEN ● SCHELLINGSTRASSE 63

*Top, sans-serif type, as used here by the type foundry
D. Stempel, was not popular in America until the 1930s,
and then only with the insistent influence of European
(especially German) designers. Above, Schla, the
nom de "graf" of Hermann Schlamelcher, had a
simple letterhead design with a very cool logo.*

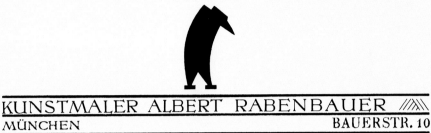

KUNSTMALER ALBERT RABENBAUER /////\
MÜNCHEN BAUERSTR. 10

ARCHITEKT PROF·BRUNO PAUL

ZENTRUM 2596
BERLIN S·W·11
PRINZ ALBRECHT
STRASSE 8A

94 *Top, the designer Albert Rabenbaur used a stylized
raven* (raben) *which also resembles an "R," as his trade-
mark. Above, the letterhead of Bruno Paul was strictly
no frills, but it efficiently expressed this versatile graphic
designer and architect's stylistic sensibilities.*

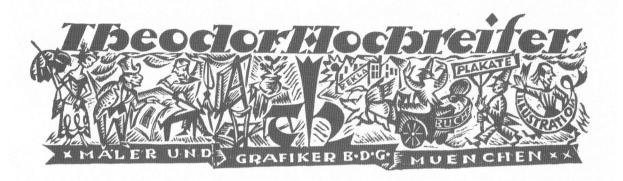

Top, "artist and designer" Theodor Hochreifer injects humor into his woodcut designs, in contrast with the many serious, sometimes pompous compositions typical in German letterheads. Above, designer Konrad Jochheim spared no expense in making his letterhead stand apart from the crowd's. In addition to producing his commercial art, Jochheim authored several books on lettering and monograms.

ADVERTISING

PLAKA

REKLAME

FARBE

IN GERMAN ADVERTISING, the gamut is run from riotous color (demonstrating the wares of ink and paint manufacturers) to deliciously rendered black and white spot advertising. Printing firms were in a fine position to exploit their services broadly, often with designs of seven colors. And there seemed no reluctance in these firms to supply gratis to the trade magazines, for the benefit of self-promotion, small-scale reproductions of posters.

IT IS CONSISTENT WITH THE HISTORY OF GERMAN GRAPHICS that the designers attended so assiduously to their own self-promotion, as numerous ads and prospectuses attest. Some of the earliest examples of posters and handbills standing out from the plain, printer-roduced variety were those that artists did to promote themselves and their exhibits.

THERE WAS, OF COURSE, PERFUNCTORY AND CRASS ADVERTISING in German newspapers and magazines, as in British and American publications of the same period. But in Germany there were also strikingly beautiful exceptions, with a forcefulness of effect rarely seen elsewhere.

MANY OF THESE ADS ARE ALMOST ENTIRELY HAND-DRAWN. Some of them are purposely casual in technique, while the rendering of others seems almost unbelievably precise. Most German designers were able letterers, and so produced a remarkable integration of lettering and design. In the case of so many trademarks—which form the basis of numerous advertisements—anthropomorphized lettering often *became* illustration.

THE FAVORED SOFT-FOCUS, LOW-CONTRAST STYLE OF GERMAN PHOTOGRAPHY from this period did not lend itself well to halftone reproduction (and proved a boon to illustrators). Ad artists desiring gray tones preferred screens of parallel lines rather than dots. Vivid patterns of black and white woven into this advertising assured good reproduction and eye-catching results, even with the poor quality of newspaper printing. The line art designs shown here seem as colorful for their bold spotting of blacks as full-color ads. And the color ads themselves are nearly blinding.

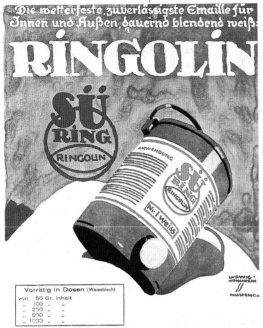

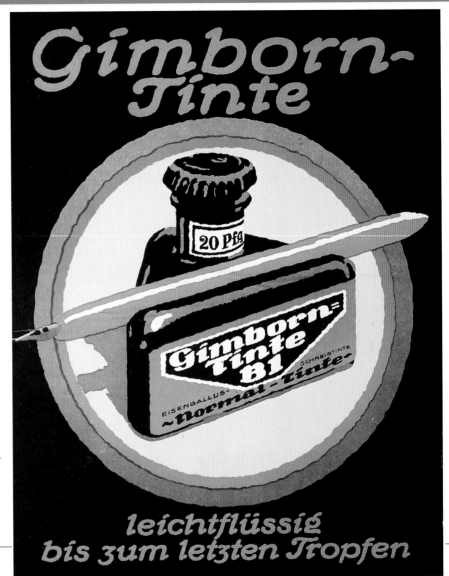

Above, an ordinary advertisement for
Ringolin enamel paint turned into an artistic
triumph at the hands of Ludwig Hohlwein, c.
1929. Right, dark, saturated opaque colors
applied with a fat, round brush (typical of
much German graphic art during the teens
and early twenties) helped Gimborn Tinte
(ink) make a bold statement.

98

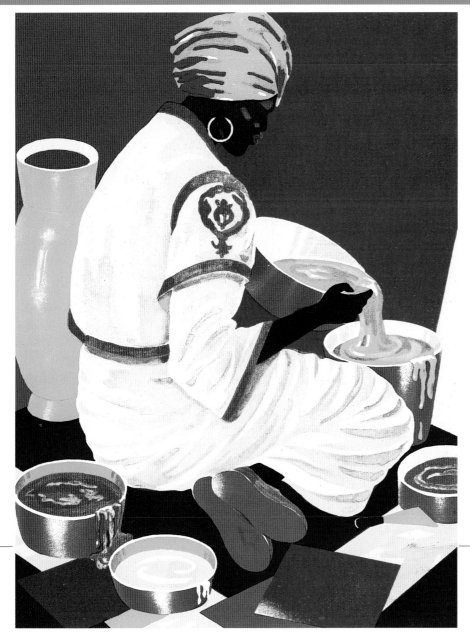

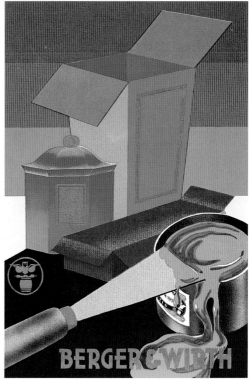

Brilliant colors and wonderful illustrations characterize these glorious printing ink advertisements from Chr. Hostmann-Steinberg'sche Farbenfabriken, left, and Berger & Wirth, above, both from the late twenties.

German advertisements from 1918 to 1929 show the rich tonal effects that are possible using only black and white.

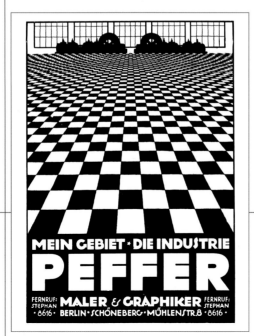

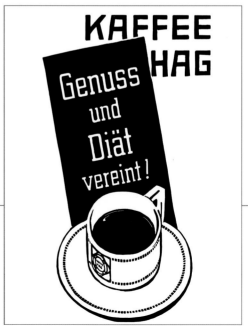

The colorful grid of rectangles in this full page advertisement for Neisch Plakat Farben (poster paints), 1930, suggests posters pasted upon a wall.

101

Left, this type foundry advertisement from 1917 displays Lucien Bernhard's "Fraktur," a font that probably originated in the artist's posters. Below, a woodcut design with a patriotic slogan by Rudolph Koch, 1933, creates a hybrid between calligraphy and his popular typeface Neuland. Below left, the illustration and lettering in this small ad provide a demonstration of what could be achieved using Heintze & Blanckertz's pen points, 1938.

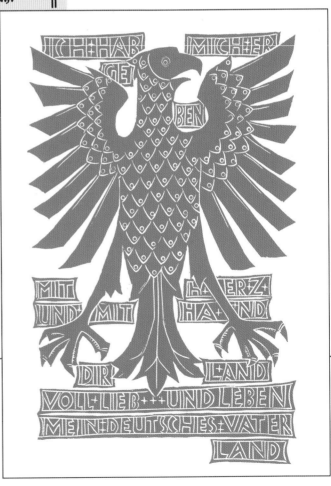

102

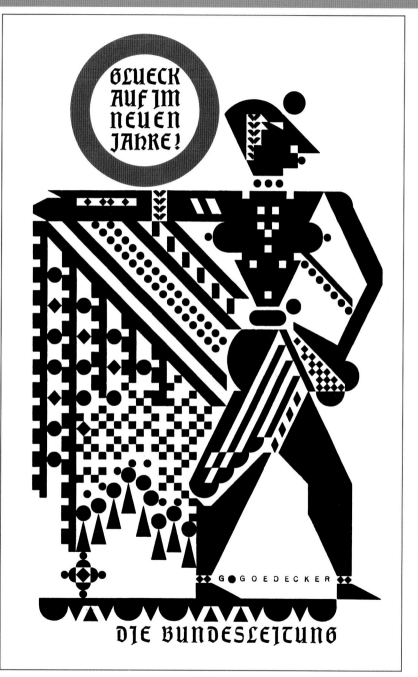

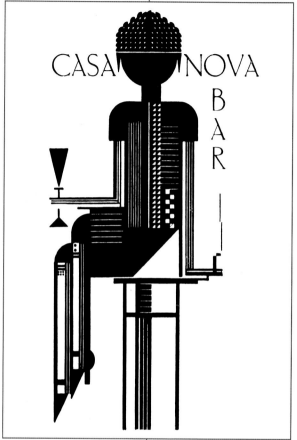

The year 1929 seems to have produced a mild craze for the ultimate in cubist illustration: pieces of metal type and borders arranged to form images. G. Goedecker employed the technique in a New Year's greeting, left, and the wonderful design above for Casa Nova Bar is by Franz Marten.

103

The trademark often became the central feature in German graphics. In this ad for Willy F. P. Fehling (a paper company), c. 1938, rainbow ziggurats festoon a heroic trademark rendered by airbrush to give a sculpted appearance.

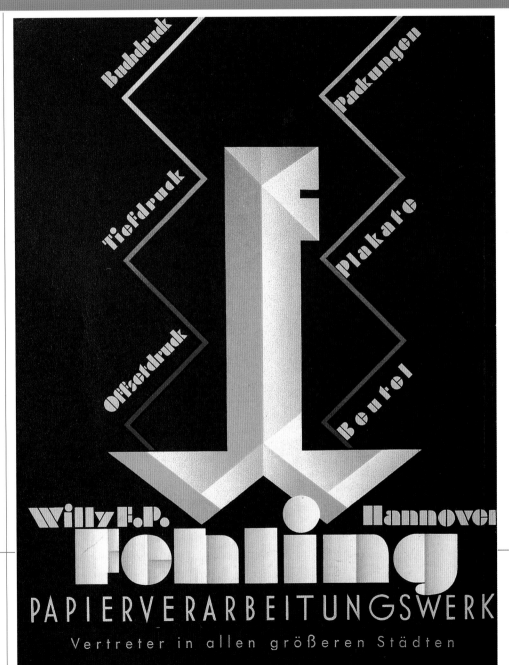

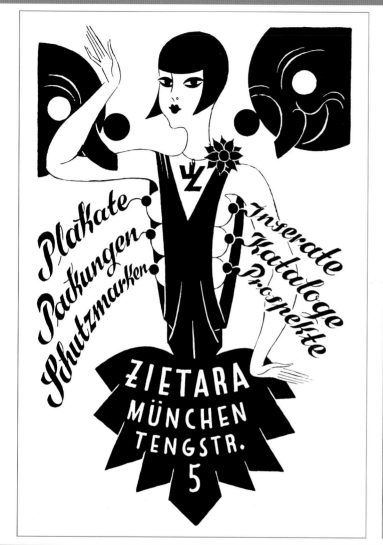

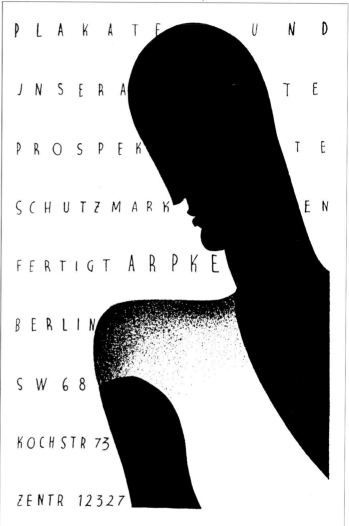

Illustrators' self-promotional advertisements offer the complete freedom usually lacking from assigned work. Valentin Zietara's ad, left, featured good drawing, great lettering, and a literally eye-popping concept. Right, Otto Arpke's ad is a marvel of dramatic, art deco stylization. Both ads are from 1927.

105

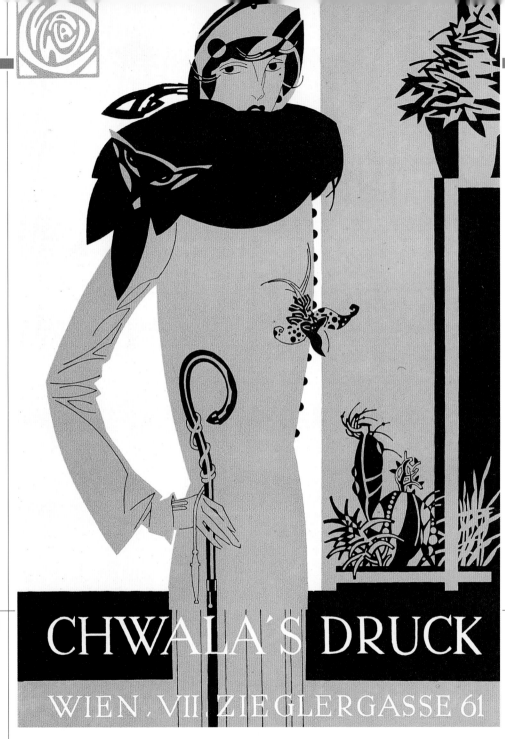

If attracting the eye is the chief objective of good advertising then Julius Klinger's intriguing drawing for Chwala's Druck, 1927, is a smashing success, though the subject matter is seemingly irrelevant to the Viennese printing firm's purpose.

CHWALA'S DRUCK

WIEN, VII, ZIEGLERGASSE 61

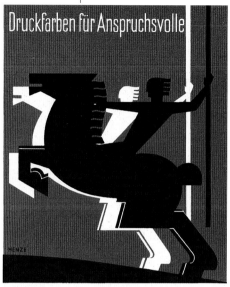

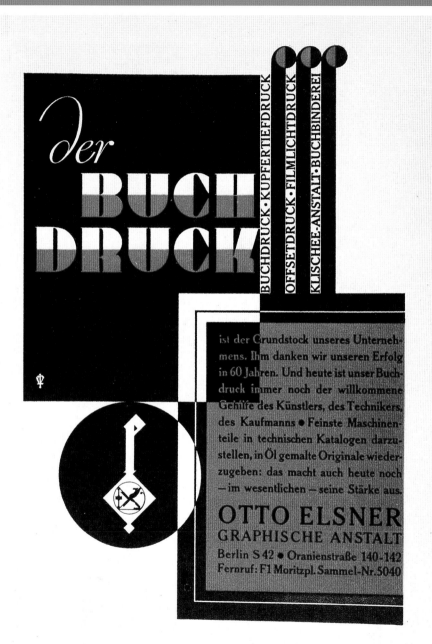

Left, *a modern treatment of typography for the printer Otto Elsner is highlighted by positive/negative interplay, 1930. Above, Chr. Hostmann-Steinberg'sche Farbenfabriken sold "printing inks for particular people" with this dynamic advertisement, 1934.*

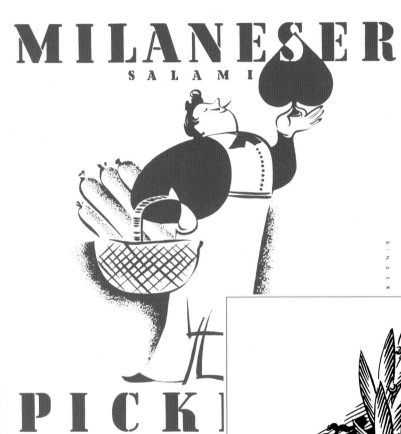

MILANESER
SALAMI

PICKI
SALAMIFABRIK ER

Two renowned poster artists, Josef Binder and Valentin Zietara, demonstrated their capabilities as line artists in small advertisements. Left is Binder's design for Pickfein Salamifabrik, 1934, and below, Zietara's Mercedes-Benz design, c. 1927.

BINDER

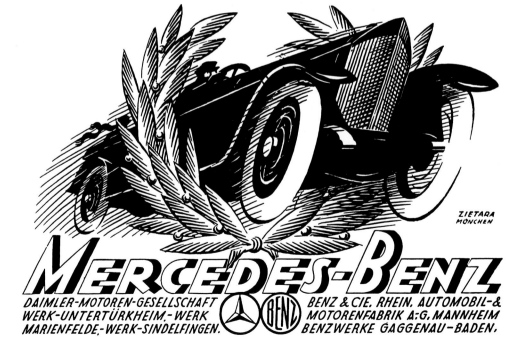

ZIETARA
MÜNCHEN

MERCEDES-BENZ
DAIMLER-MOTOREN-GESELLSCHAFT BENZ & CIE. RHEIN. AUTOMOBIL-&
WERK-UNTERTÜRKHEIM,-WERK MOTORENFABRIK A:G. MANNHEIM
MARIENFELDE,-WERK-SINDELFINGEN. BENZWERKE GAGGENAU-BADEN.

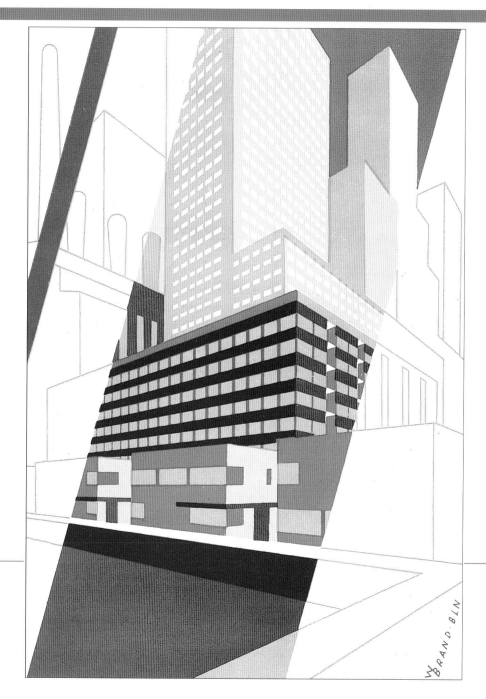

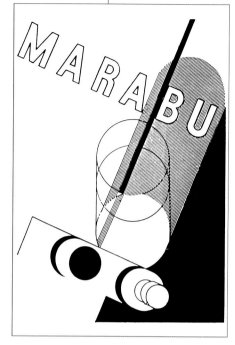

Left, to show the ink-handling qualities of their paper "Sevilla," Krause & Baumann used an architectural illustration by Werner Brand as an insert advertisement, 1929. Above, a striking advertisement by Carl Amann for Marabu paints is a study in tonal contrasts and composition.

GEBRAUCH

COVERS

SPUT

von ROBERT HEY

ungen des NUMMER 8-9 AUG·SEPT· 1915

EINBAND

Reflamefachleute

IN DESIGNING COVERS the German artists observed most of the same aesthetic rules that they did with posters. One exception stands out; covers allowed greater experimentation with media that might not have "read" in a poster. Thus fine woodcuts, with their subtlety of arrangement, are often seen in covers such as those created for the graphic arts publications *Das Plakat, Gebrauchsgraphik,* and *BDG Blatter.*

CONTRASTING WITH THE MODERN CONCEPT of the masthead logo as sacrosanct icon, it was quite acceptable through the 1920s and 1930s to vary title lettering so as to blend it with the art on the cover. This is especially evident in *BDG* covers, where the artist was given the widest latitude and the marriage of masthead lettering with graphics is expertly done.

ON COVERS FOR PUBLICATIONS SUCH AS *Gebrauchsgraphik* and *Das Plakat* magazines the artistic styles resemble those on *The New Yorker.* Each is a graphic statement complete within itself, bearing no particular reference to the interior subject matter. Some of these images are therefore closely aligned with a definition of fine art as opposed to commercial art.

THE GERMAN EAGLE WAS NEVER SO FRIGHTENING as in Karl Schulpig's dramatic cover for *Mitteilungen des Vereins Deutscher Reklamefachleute.* Soon the eagle, temporarily tattooed with a swastika, would cast its ominous shadow over the world. The more benign owl was also popular in German graphics. In the tradition of *Simplicissimus* and *Jugend,* the covers of *Uhu (owl),* blown up to poster scale, served as perfect advertisements for themselves. In doing so they reinforced the similarity of effect between posters and cover art. Thus it was not surprising when *prospekte* (brochures) began to take the place of large posters.

SOME GERMAN COVER DESIGNS were as typically Victorian as any comparable period American cover. Yet into the 1930s American design had nothing to compare with the covers for *V. D. I.,* and *Deutschland Ausstellung.*

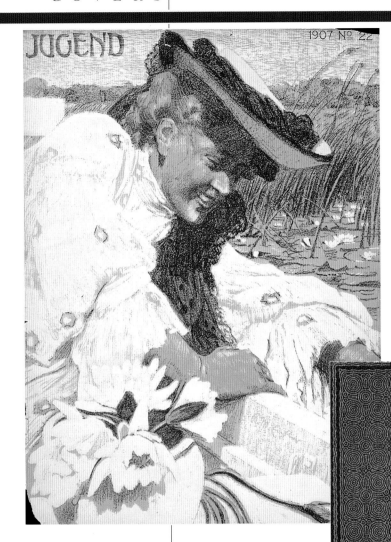

Left, *a beautifully subtle, two-toned lithograph by R. M. Eischer (spelling unclear) for* Jugend (Youth), *1907. The well drawn maiden, while classically beautiful, also looks typically German. Below, the seeds of modernism can be found in this brochure cover for Benz automobiles, 1909, by F. H. Ehmcke. And yet the warmth and hand-drawn aspect of the design are its links with contemporary graphics, the world over.*

112

BENZ

1909

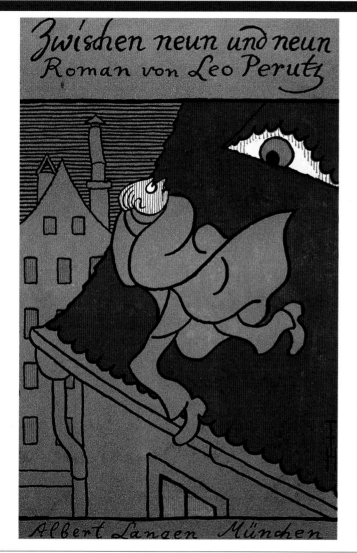

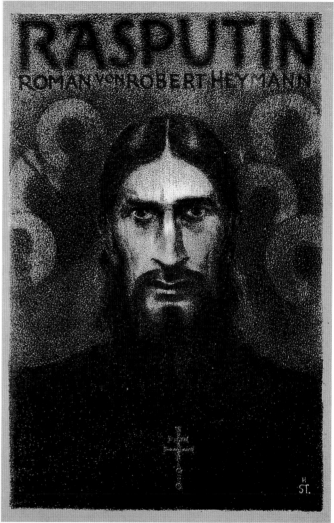

Thomas Theodor Heine's fine sense of composition transforms an otherwise casual cartoon illustration into a haunting book cover for Zwischen neun und neun (Between Nine and Nine), 1918. Heine's colors, blue-green and vermillion, were favorites of German designers.

The character of Rasputin is admirably evoked in this one-color design in lithographic pencil by Hugo Steiner, 1918. Though powerful images, both Steiner's and Heine's book covers are considerably understated by today's standards.

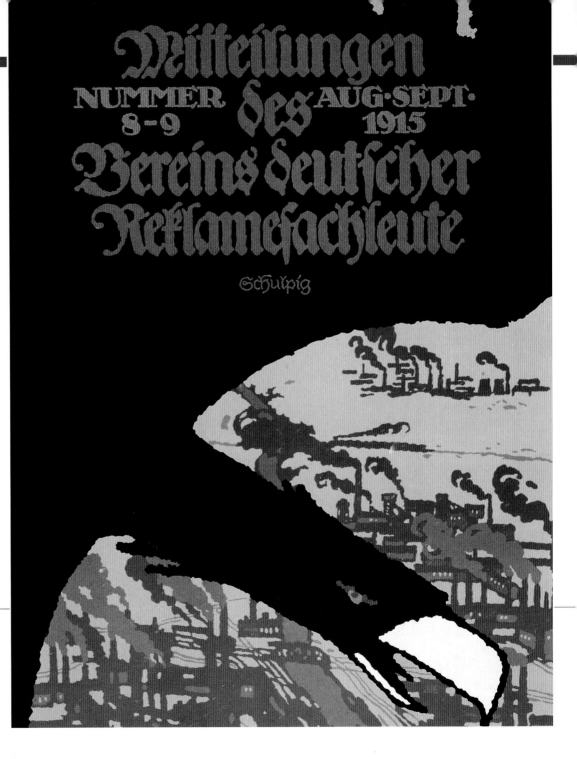

Why is Karl Schulpig's cover for a seemingly innocuous Announcement of the Union of Advertising Experts, 1915, made so ominous, unless the smoking factories in the background are busily manufacturing munitions for World War I?

114

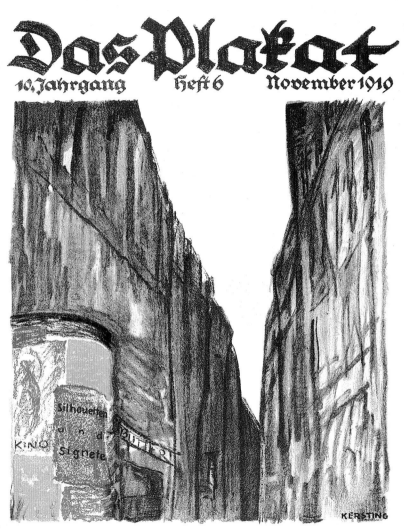

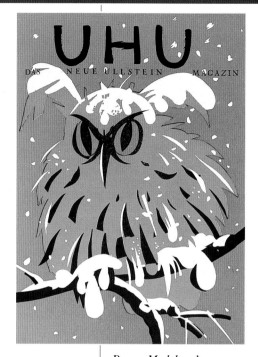

Busso Malchow's cover (and poster) design for Uhu *(Owl) magazine utilized the bird to make a statement almost as powerful as Heine's bulldog cover for* Simplicissimus.

Left, the Litfasssäule *(pillar for displaying posters) shown on this cover of* Das Plakat (The Poster), *from 1919, announces the issue's subject: "Silhouetten und Signete." Cover designed by Walter Maria Kersting.*

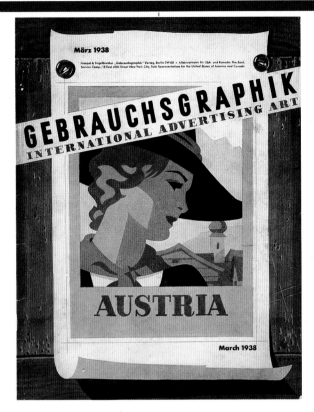

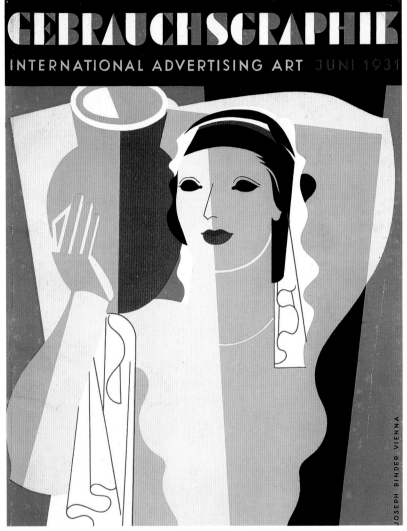

The influential graphic arts journal
Gebrauchsgraphik *brought German artists interna-*
tional exposure. Articles also featured designers
from England, France, and America, and portions
of the magazine were translated into English—
often humorously. Austrian illustrators Kosel and
Josef Binder provided covers above and at right,
respectively, for Austrian-themed issues.